Oceanside Museum of Art

OMA DIRECTOR'S STATEMENT

Oceanside Museum of Art takes great pride in presenting Quilt San Diego's 7th juried exhibition, **Quilt Visions 2002**. It is a particularly appropriate show for OMA's public spirited exhibitions program which, since its beginnings, has championed the fiber arts. The San Diego region is home to a remarkable number of quilt makers, quilt organizations, collectors and aficionados. We experienced this high level of interest in 1998 when the museum presented Full Deck Art Quilts, curated at the Smithsonian Institution Traveling Exhibitions Service and featuring the work of 52 leading American quilt artists. Subsequent exhibitions presenting work of the Manhattan Quilters Guild and the story quilts of Faith Ringgold were greeted with equal enthusiasm. The quilter's art, and textile arts in general, are highly regarded in San Diego County.

We now add to the museum's history the extraordinary legacy of Visions. Quilt San Diego, organized in 1985, set out to "promote quilt making as an art form" by showcasing distinguished quiltmakers predominately of San Diego County and sourthern California. That regional focus quickly evolved into an international scope. This exhibition has been selected from a field of 900 works submitted from no less than 17 countries. Quilt Visions 2002 represents the work of 45 artists who are very clearly masters of the form.

The dedication of a large number of individuals has made this project possible. Quilt San Diego has done an exceptional job of bringing this challenging project together and I wish to thank Julia Zgliniec, Miriam Machell and the many QSD volunteers for their commitment and high level of professionalism. I extend my gratitude as well to our distinguished jurors Inez Brooks-Myers, Rebecca A. Stevens, and Lynn Lewis Young for performing the formidable job of selecting the exhibition from the many wonderful pieces submitted. I also wish to acknowledge and thank Trish Williamson, a long-time member of the museum's Exhibitions Committee who has been responsible for organizing all of OMA's quilt shows to date. Although she no longer resides in the area the museum continues to benefit from her curatorial expertise. I especially wish to thank Peggy Jacobs, Chair of OMA's Exhibition Department and Exhibit Designer for OMA. Her extraordinary vision and elegant sense of design are reflected in all of our exhibits.

James R. Pahl
OMA Executive Director

Jurying Philosophy

We define a work of art as a work that is in some way extraordinary. It is expressive and invites us to see ourselves and the world anew, or inspires us in a new way.

We want the best in quiltmaking today. It is certainly not our intention to shock the public. While it is important to represent the range of today's quiltmaking, it is equally important that each quilt possess a vitality of its own and be able to stand alone as well as work with the other quilts to provide an exhibition that somehow "gels" together.

We want the public to see a range of quilts, some that perhaps may initially "feel" familiar and also those that will make them stop and think, evoke an emotion, create an opinion. We want quilts that derive from the necessity to communicate, that speak from the soul of the quiltmaker.

We want quilts that flow with color, sparkle with excitement, those that make visual impact, and those that are so subtle that one must look closely to see unusual use of fabric, high technical skills, and other marvelous effects used to create the design.

We want all those wonderful, incredible quilts that express the quiltmaker's creativity. We want an exhibit that compels the viewer to return for more than one look.

Inez Brooks - Myers

Inez Brooks-Myers is Curator of Costume and Textiles at the Oakland Museum of California, where she's been for over 28 years. She's worked on a variety of exhibitions including: American Quilts: A Handmade Legacy, Crazy Quilts, Lia Cook: Material Allusions and Well Heeled. Presently she is organizing Iconic to Ironic: Fashioning California Identity which will open in March, 2003.

Brooks-Myers is a Fellow of the Costume Society of America and is also an active member of the Textile Society of America and the International Council of Museums.

Visions 2002, one of the most prestigious juried quilt exhibitions in the world, is the collaborative effort of Quilt San Diego, the quilters who entered the competition, the Oceanside Museum of Art and the three jurors.

Quilt San Diego is a tireless group of sweet-tempered volunteers who received the entries and assisted the jurors by projecting slides of the entries and keeping the voting tallies as quickly as they were voiced. From 17 nations hundreds of men and women submitted 867 quilts with the hope that they might be successful in having their work chosen for *Visions 2002.*

The Oceanside Museum of Art, a new and elegant location for the exhibition, provided a fresh venue and an experienced, dedicated staff.

The final element of the *Visions* equation is the three-person jury. It is an honor to be entrusted with the formidable task of judging the fine entries that were sent to Quilt San Diego. The quality of the work submitted was superlative. How much easier it would have been had the gallery been constructed with elastic walls, and a larger number of quilts could have been included.

As a curator I look at quilts for many reasons. In this instance I was examining the quilts for their artistic merits: the concept behind the creation of the quilt and how it is expressed, the use of color, texture, line, form and pattern, the interpretation of the idea, and the skill in the final presentation. Building a quilt is more than mere sewing; it is opening one's mind and heart to the statement rendered in cloth.

Looking at the pieces in the exhibition, and featured in this catalogue, it becomes obvious that quilting has evolved the world over. Not so long ago quilts were universally understood as the cozy covers you put on beds, and *art quilts* required explanations—what bed would that fit?—what pattern is that? Now, happily, quilts can be executed in traditional patterns, by artists using license and creativity to arrive at new solutions. For example, the work of Ellen Oppenheimer, *FG Block ECB,* employs a traditional pattern along with her own eye-dazzling colors and printed textures, creating a unique statement. Beatrice Lanter's log cabin quilt, *Lights,* is another example of new visions in traditional patterns. Sue Pierce deconstructed her quilt, *Flag Waving on the Home Front,* allowing each one-patch quilt block, composed of familiar domestic textile memories, to stand on its own, 24 individual pieces creating the whole. *Stick Quilt,* created by Lorre Hoffman used a non-traditional batting, sticks, but was organized in a comfortable grid.

Wendy Huhn in *Save the Last Dance for Me,* Elizabeth McDonald in *Stumps to the City* and Cynthia Myerberg in *Cut Out To Be a Good Wife* all bring a societal theme to their quilts.

Several pieces submitted used art metaphors. The subtle (and not so subtle) wicked humor of John W. Lefelhocz is a tongue-in-cheek homage to a familiar impressionist artist; it is all the more satisfying because of Lefelhocz's technical skill in his *Monet over Money.* In *Bamboo Boogie Woogie,* Liz Axford combined her appreciation of Mondrian with her quilter's eye and her finely dyed textiles. *Party's Over* is a startling painting rendered in cloth, through appliqué, by Denise Tallon Havlan. She describes it as "suggesting adolescence." I found it more than a suggestion: the young girl, surrounded by party accoutrements, addresses the audience in a haunting manner similar to portraits by masters, where the subject faces the viewer with a startled innocence, somehow anticipating the inevitable change that will occur very soon.

The work in *Visions 2002* represents much of the best in the quilting world today. This exhibition is bound to have an impact on contemporary quilting, giving quilters a new and expanded menu of ideas, materials and techniques to explore.

Rebecca Stevens

Rebecca Stevens is the Consulting Curator, Contemporary Textiles at The Textile Museum in Washington, D.C. She is the author of numerous articles on contemporary American textiles and has served on the editorial board of The Textile Museum Journal. Her articles have appeared in American Craft, Fiberarts, Shuttle, Spindle and Dyepot and TextileForum. She has curated exhibitions of contemporary textiles for The Textile Museum, the Renwick Gallery of the Smithsonian American Art Museum, the Anchorage Museum of History and Art, Anchorage, Alaska and the Missoula Museum in conjunction with the University of Montana. Stevens has served as a juror for many exhibitions of contemporary fiber art, including "Quilt National", "Fiberart International '99 in Pittsburgh, PA, Small Expressions 2000 for the Handweavers Guild of America and Contemporary Tapestry West Coast in Seattle, Washington in the fall 2000. She also served on an international panel to select works for a multi-national contemporary tapestry exhibition honoring the 1000th anniversary of the founding of the country of Hungary for the Museum of Fine Arts, Budapest. Stevens is co-editor of Ed Rossbach: 40 Years of Innovation & Exploration in FiberArt and coordinating curator for the exhibition of that title.

Mr. Rossbach had a profound influence on contemporary textile artists and is credited with bringing the beauty of Japanese basketry and dyeing techniques to the attention of artists in the United States. In addition to curating The Kimono Inspiration and co-editing its accompanying book, Mrs. Stevens has lectured at the American Center in Kyoto on this subject. Her most recent project was an exhibition and catalogue, Technology as Catalyst: Textile Artists on the Cutting Edge at The Textile Museum, Washington, D.C., which explores the use of digital technology by six textile artists: Lia Cook, Susan Brandeis, Junco Sato Pollack, Cynthia Schira, Hitoshi Ujiie, and Carol Westfall.

Quilt Visions 2002 is a collaborative enterprise made possible by the interaction of many participants, each playing a vital role. Quilt San Diego/Quilt Visions whose members sponsored and organized this impressive series of exhibitions provided the foundation and the critical impetus for this exhibition. The staff of the Oceanside Museum of Art brought the idea of Visions 2002 into physical reality. The jurors made the necessary selections from the hundreds of worthwhile entries and, of course, the artists whose creative expressions find voice in the art quilts provide the content.

Each time I am asked to jury an exhibition, I think about both the pleasurable and the onerous aspects of the process. The thrill of seeing new work, meeting new artists vicariously via their slides, and becoming reacquainted with artists already known to me is a pleasure. The task of selecting from among all the entries which works will be included which excluded is a heavy responsibility. The choices the jurors make prescribe what the exhibition visitor will see and shape the visitors' understanding of the subject. It is never easy to choose nor should it be. It takes time and thoughtful consideration. The members of Quilt San Diego/Quilt Visions led by their president Julia Zgliniec gave us the time to make our judgements and made this difficult process run smoothly.

Each of the three jurors bought her own perspective, knowledge, and experience to the task of selecting the exhibition from the 867 works entered. The works submitted represented a panoply of artistic ideas. Some were formal studies, investigations of color, shape, and line. Others were personal statements, glimpses into the psychological world of the maker. Some works were whimsical and optimistic while others were dark and foreboding. Our job was to select those works that best expressed the idea of the maker in an original and skillful way regardless of the subject matter or the artist's aesthetic point of view.

The history of the art quilt is little more than twenty-five years old. But in that short time the field has produced powerful works that address the human condition in all of its variety and complexity. The works included in Quilt Visions 2002 reflect the dynamic "vision" of today's art quilts and pave a path for the art quilts of tomorrow.

Lynn Lewis Young

Lynn Lewis Young, publisher/ editor of Art/Quilt Magazine, has been involved in many aspects of quiltmaking since 1977. She is an active quiltmaker in both traditional and contemporary styles, a teacher of quilt techniques, design and professionalism and an author of many articles for publications. In addition, Lynn has studied antique quilts and has a collection of antique quilts and tops, ethnic textiles, plus small contemporary quilts in addition to her own work. She has been a frequent attendee and judge for many quilt shows and has a broad appreciation and knowledge of contemporary quilts, both traditional and non-traditional. She has worked in the past for the International Quilt Festival/ Quilt Market and served on the board of many quilt organizations to which she belongs, including being president of AIQA (now IQA) and the Quilt Guild of Greater Houston and editor for the Studio Art Quilt Associates. In 1994 Lynn began publishing Art Quilt Magazine, a magazine devoted to the art quilt. She is both publisher and editor of this quarterly art magazine for quilts.

Not long after the *QuiltVisions 2002* jurying process, a fellow quilt aficionado queried me on the growth of the art quilt as a viable art medium. Had I seen anything new and exciting in art quilts, any different considerations of the medium or of the message therein?

Innovation in any art medium can take form in technical advances— new methods, new levels of expertise and craftsmanship. Imagery can develop in totally new ©how a total re-vamping of an art form and cause a new chapter to open. The art form, the quilt, will not be thought about in the same manner from that point onward.

During the jurying process for *Quilt Visions 2002*, our directives from the committee stressed excellence, innovation, originality and artistic content. We as jurors distilled an overwhelming number of excellent quilts – a huge number of which could have easily been selected for a broader show – into a concise statement of what we saw as most innovative and artistically exciting in quiltmaking today. Many examples of well-developed improvisations on the geometry of the quilt failed to rise above the milieu of that popular method of creating one's own thing that often is too easy, too facile, too much fun to develop more truly original artistic content. Great-looking examples of surface design collaged together, while pleasing to gaze upon, lacked the content of art that results from an ongoing pursuit of original, personal imagery derived from the artist's hand.

When looking over the works selected, what element of innovation can be seen throughout *Quilt Visions 2002*? What is the spark, the key that opens a new view of the quilt medium? Individual quilts in the show seem quite varied and show the full range of contemporary quiltmaking techniques. Some take those techniques and push what can be done with them, pushing the definition of 'quilt' by their choice of materials and the way they handle the quilt elements of surface, layers and stitch. Some reconsider the traditional design basis of the quilt and develop a new dialog with the geometry of the past. Some develop their surface design techniques into compelling imagery that goes beyond solely the effect of the technique. Some speak to contemporary life, some to a greater meaning of life.

These very differences point to the commonality in all works in this exhibit. All artists included in *Quilt Visions 2002* hone the medium for their own artistic expression, tempering the quilt through their individualistic vision with an unwavering pursuit of artistic excellence. Not only do they push the medium and try different things, they do it with artistic integrity. Hopefully the jury's efforts to distill the essence of innovation in today's quilt art will be clear to viewers as they enjoy the exhibit quilts. I further hope visitors, after seeing the quilts, will take home a new view of the art of the quilt and open a new chapter in their appreciation of the contemporary quilt that is *Quilt Visions 2002*.

Awards / Sponsors

The **Quilts Japan Prize**, sponsored by Nihon Vogue, a Japanese corporation, and awarded in 1994, 1996, and 1998, will once again be awarded to a QUILT VISIONS 2002 artist. At the conclusion of this year's jurying process, the jurors selected **Jane Dunnewold**, San Antonio, Texas, to receive the award for her work *Two Sides To Every Story*. The objective of the Quilts Japan Prize is to express gratitude for the continued growth of the Japanese quilt, which is due greatly to American quilters, and to pay respect to the predecessors of quilt making. With this award, Nihon Vogue hopes to play a role in the development of quilt making by helping to link the ties between Japanese and American quilt makers.

The **Sponsor's Award** is given by Rosie Gonzalez of Rosie's Calico Cupboard Quilt Shop who selected **Patricia Goffette** to receive the award for *Polar Prowler*. Rosie said, "I was looking at the photos of the quilts and this one stopped me cold. A bear was walking right out of the picture to me. It was awesome. Not scary or ominous or menacing, just goose-bumps awesome. Because I love fabric, I was very impressed by the artist's use of so many different fabrics to make a quilt that actually gives the feeling of a real bear. My congratulations to Patricia Goffette."

The **CREAM Award**, (Cathy Rasmussen Emerging Artist Memorial Award) is awarded by The Studio Art Quilt Association, a non-profit national organization founded to serve artists working in the quilt medium and presented to an artist who has had their work in this exhibition for the first time. The CREAM Award is so named in memory of SAQA's first executive director, Cathy Rasmussen. The board of directors of SAQA has chosen **Robert Leathers** of San Diego, California, formerly of Ithaca, New York, as the recipient of this year's award for his work *After Angkor*.

President's Choice Award, given by Canyon Quilters of San Diego, a non-profit organization established in 1985 to meet the needs of local quiltmakers in San Diego County, is chosen by the President of Quilt San Diego/Quilt Visions. Julia Zgliniec chose **Inge Mardal and Steen Hougs** to receive this award for *Crow's Nest II.* "This quilt exemplifies the perfect blending of technique and imagery to create a mood and evokes in me a physical response to the work."

Williamson Family Memorial Award Patricia Williamson and Carol Bennett created the award in memory of their parents Keith and Ethel Williamson. The criterion for the award was "innovation in the contemporary interpretation of traditional quilt designs and techniques." Jurors were asked to make recommendations for the award and the family made the final selection. *Flag Waving On The Home Front*, created by **Sue Pierce** of Rockville, Maryland, is the recipient of this inaugural award. According to Patricia Williamson, *"Flag Waving On The Home Front* has a quiet force and the viewer responds to it on many levels. When seen by members of our family, this work evoked fond reminiscences of our parents and grandparents."

Sponsors

Quilt San Diego/Quilt Visions has received significant support from these corporate sponsors in producing QUILT VISIONS 2002 and this catalog. We are grateful for their financial assistance and commitment to the quilt as art.

Rosie's Calico Cupboard Quilt Shop • Friends of Fiber Art International
Flying Geese Quilters Guild • Friendship Quilters Guild of San Diego • Robert & Patricia Klem
Amidon Quiltworks • Canyon Quilters of San Diego • Creative Expressions of Palm Springs
Glendale Quilt Guild • La Jolla FiberArts • Patchwork Plus • P&B Textiles • Quilters' Choice
Sew Hut • Sew Much Better • Sowing Sisters Quilt Shop • Starseed Foundation • 21st Century Bob

The Quilts

Virginia Abrams	In the Jungle
Susan Shie and James Acord	The Cream and Sugar/Lovers: Card #7 In The Kitchen Tarot
Ann M. Adams	Kuba Kantha
Jill Ault	Window
Liz Axford	Bamboo Boogie Woogie I
Elizabeth Barton	Farne Islands
Sharon Bell	Genesis
Meredyth L. Colberg	Bouillabaisse
Judith Content	Marsh Light Series "Eclipse"
Cindy Cooksey	Down-and -Out Moon
Jane E. Dunnewold	Two Sides to Every Story
Jane Einhorn	Nestled
Noriko Endo	Nature In New Zealand
Pamela Fitzsimons	Sandstone Cloak
Dale Fleming and Dawn Guglielmino	Darwinian Squares
Britt Friedman	Winter Tree
Patricia M. Goffette	Polar Prowler
Denise Tallon Havlan	Party's Over
Lorre Hoffman	Stick Quilt
Wendy Huhn	Save the Last Dance for Me
Melody Johnson	Foursquare Circles
Mi Sik Kim	The Forest
Beatrice Lanter	Lights
Robert Leathers	After Angkor
John W. Lefelhocz	Monet Over Money
Denise Linet	Aftermath
Shulamit Liss	Landscape in Grey
Linda MacDonald	Stumps To The City
Inge Mardal and Steen Hougs	Crow's Nest II
Lori Mason	Eva's Night Out
Eleanor McCain	Moss
Karen Miller	100 Treasures
Cynthia Myerberg	Cut Out To Be A Good Wife
Jacquelyn R. Nouveau	Jarred Memory III
Elsbeth Nusser-Lampe	Potamogeton
Ellen Oppenheimer	"FG Block ECB"
Charlotte Patera	Touch Tone Dilemma
Sue Pierce	Flag Waving On The Home Front
Dinah Sargeant	Gravity Girl has a Dream
Connie Scheele	Deciduous
Carol Schepps	Color Squares 1
Fran Skiles	Red Birds Nest
Thelma Smith	Left Turn Lane #15
Nelda Warkentin	Salmon Flash
Barbara W. Watler	Fingerprint Series #24 Seldom Seen

In The Jungle

89" x 48"

Hand Dyed Cottons by the Artist
Machine Pieced
Machine Quilted

Virginia Abrams

Hockessin, Delaware

The mature dark greens and browns of the jungle intermingle with flowering vines and young shoots introduced using improvisational piecing techniques. Patches of light filter through to the jungle depths.

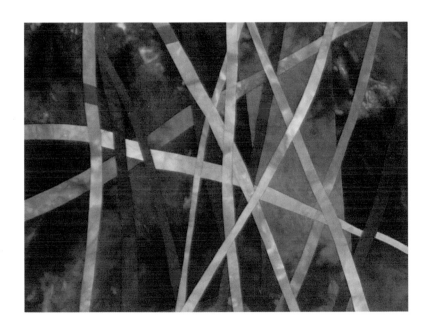

Detail

Improvisational curved pieced construction techniques create this abstract design.

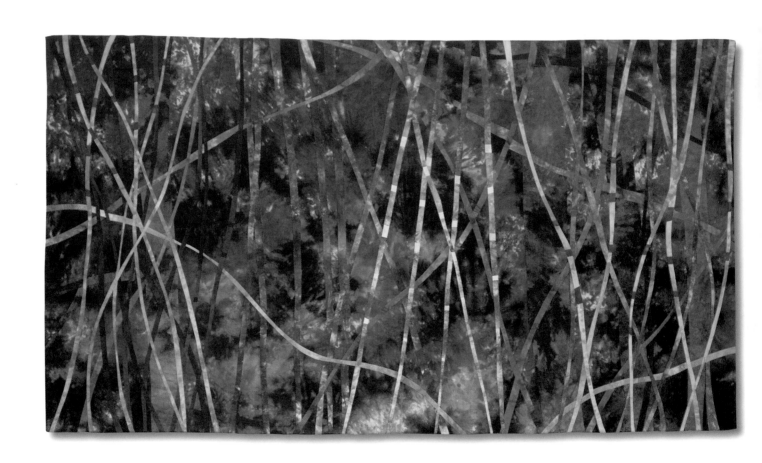

The Cream and Sugar/Lovers: Card #7 in the Kitchen Tarot

25" x 35"

Hand Embellished
Hand Quilted
Whole Cloth Painting
Hand Embroidery
Machine Stitching

Detail

Machine stitching covers the cursive writing and the surface is enhanced with beading.

Susan Shie
and
James Acord
Wooster, Ohio

The Cream and Sugar is a whole cloth painting on fabric, which was begun as an airbrush painting and then mostly hand sewn and embellished. It's the seventh piece in our Kitchen Tarot series of quilts. My personal made up saint, St. Quilta the Comforter, takes the place of the preacher who marries the lovers. She's smiling down, giving her blessing to the lovers, who look suspiciously like Jimmy and me! We're kissing under a heart with our initials carved into it.

The actual creamer and sugar bowl are modeled after my lovely Fiesta Ware pieces. I consider the creamer as symbolizing the male lover and the sugar as the female. You can figure that out for yourself. I put a St. Q tomato pincushion on my side, since I love to sew, and I gave Jimmy a fish, since he fishes.

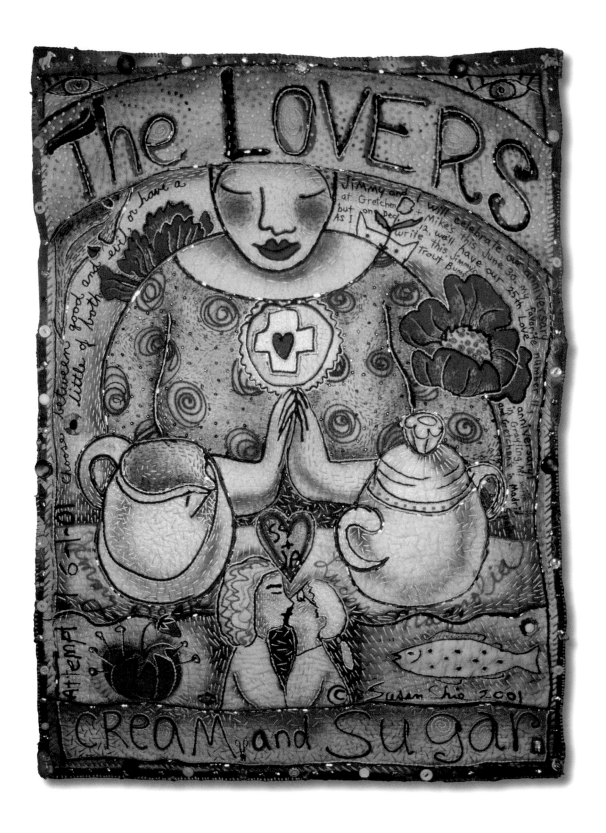

Kuba Kantha

Ann M. Adams

32" x 38"

San Antonio, Texas

Hand Dyed
Machine Pieced
Direct Applique
Hand Quilted
Machine Quilted

I am referencing Kuba cloth made by men in the African Kingdom of Zaire, and the Kantha stitch characteristic of textiles made by women in India. The calligraphic figures suggest to me dance movements and written language. The commitment to the hand stitch became a welcome ritual and meditation.

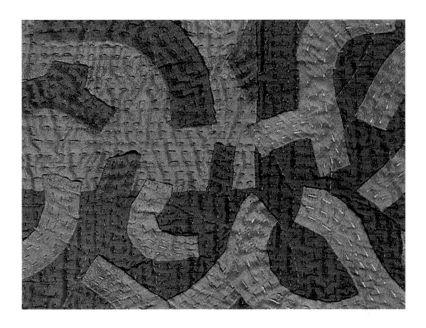

Detail

The concentric rows of stitches create a pleasing contrast with the rythm of the irregular shapes.

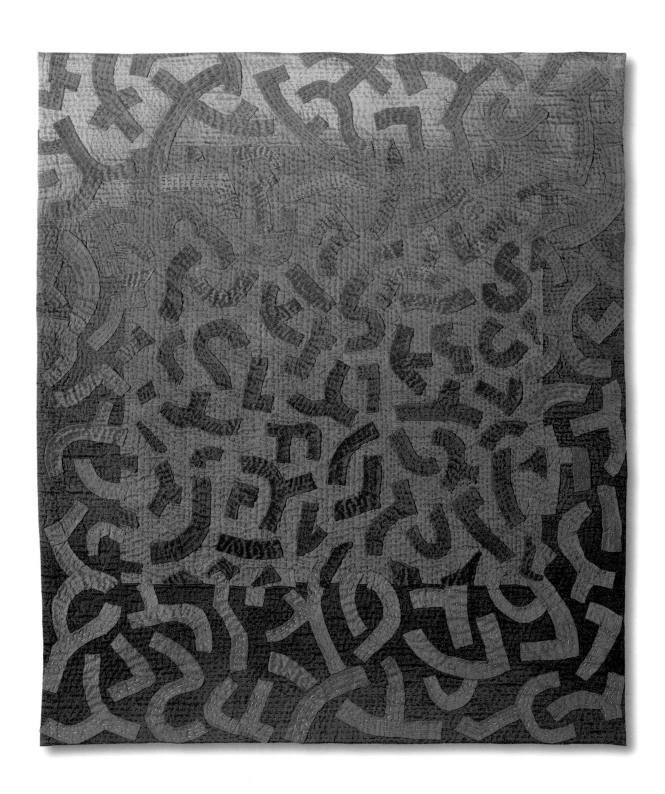

Window

35" x 34"

Pieced Hand-dyed Silk Organza
Dyed Silk Batting
Machine Pieced
Machine Quilted

Jill Ault

Ann Arbor, Michigan

"Window" uses the transparency of silk organza to allow the viewer to peer into the structure of the quilt. The top layer is pieced organza, some patterned with potato dextrin resist. Looking through the surface window, the viewer can see cut out silk plant shapes and the dyed silk batting.

Detail

Two or more pieced fabrics are layered together. The transparency of the silk allows all layers to interact. I've used silk batting, which accepts dye well, to add a visually active element to the work.

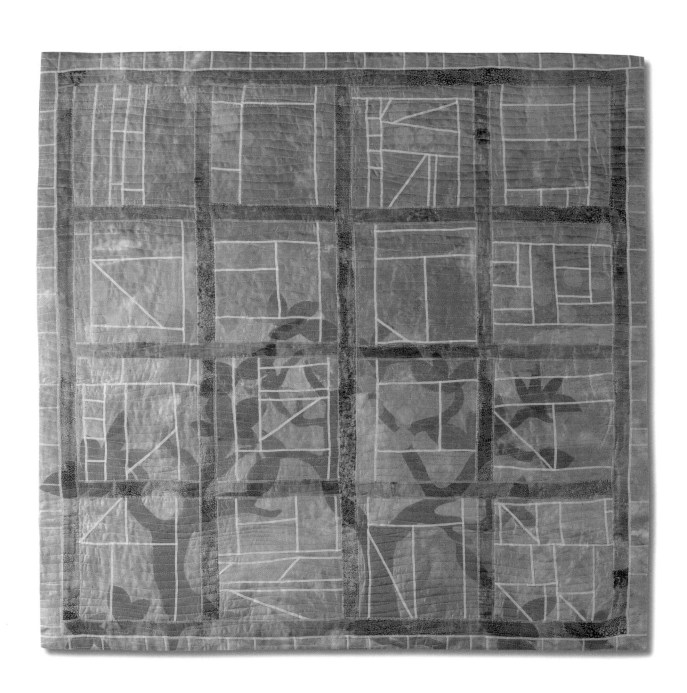

Bamboo Boogie Woogie I

Liz Axford

60" x 44"

Houston, Texas

Hand Dyed Cottons
Machine Pieced
Machine Quilted

For years, my husband tried to convince me - unsuccessfully - that we should plant bamboo as a screen in front of our house. He finally wore me down. Though the bamboo has failed to take over the yard (as I'd feared), it has instead taken over my psyche. I love everything about it: its strength and resilience; its grace and elegance; the way the light filters through it; the sound of it rustling in the breeze.

Detail

I am now a "card-carrying member" of the American Bamboo Society.

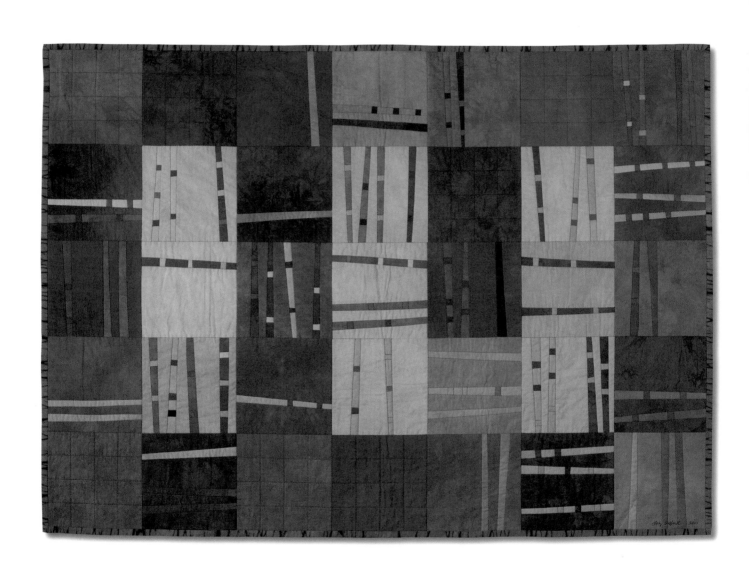

Fame Islands

47" x 60"

Machine Pieced
Direct Applique
Machine Quilted

Elizabeth Barton

Athens, Georgia

I wanted to make a piece about water - moving water that is alive and organic - the energy and movement, the rhythms - the slow glug and the fast roil, the splash and the spray, the circularity of the drops of water, the sinuous forms of ripples.

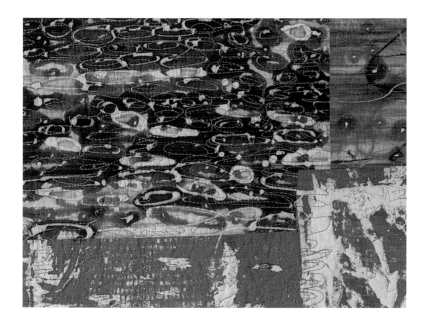

Detail

The fabrics are screen printed with Procion MX dyes, then cut and pieced.

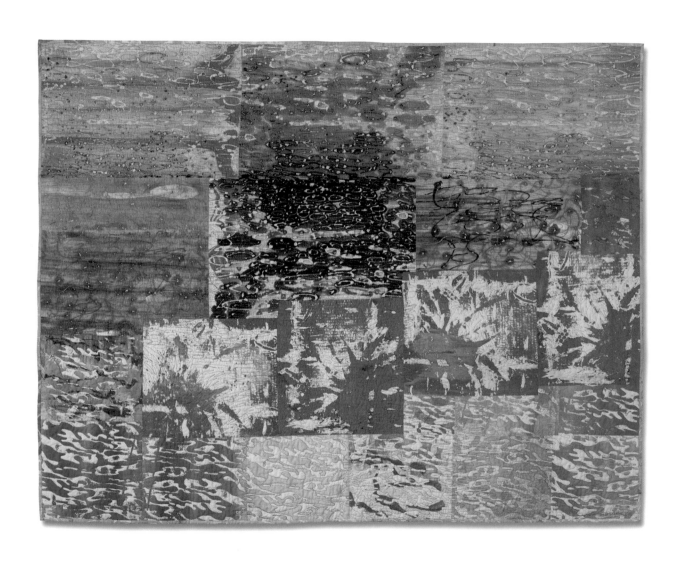

Genesis

Sharon Bell

52" x 56"

Shaker Heights, Ohio

Hand Quilted
Surface Painted and/or Dyed by the
Artist

"Genesis" is the first of seven quilts visually interpreting biblical titles. As the title suggests a beginning, I thought it was necessary to keep the composition minimal without sacrificing interest. This work also is the beginning of combining two disciplines I have been pursuing separately, quilting and painting. The dichotomy of the control from the quilting combined with the free application of paint creates the interest. This quilt is also a contrast between the almost traditional grid quilt pattern and bound edges and the non-traditional addition of paint to a non-stretched, non-gessoed surface. It is an exciting time to be working in fiber. This world is experiencing an explosion of interest by both artists and viewers. Again, I wanted to show this change and have shown the quilt as a beginning to open or explode.

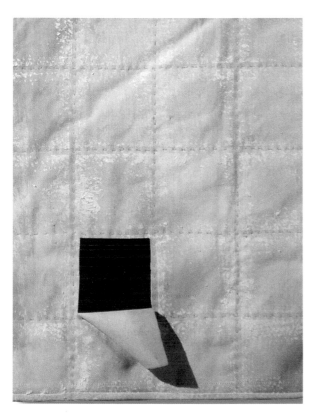

Detail

Dimensional flap "opens" to reveal inner surface.

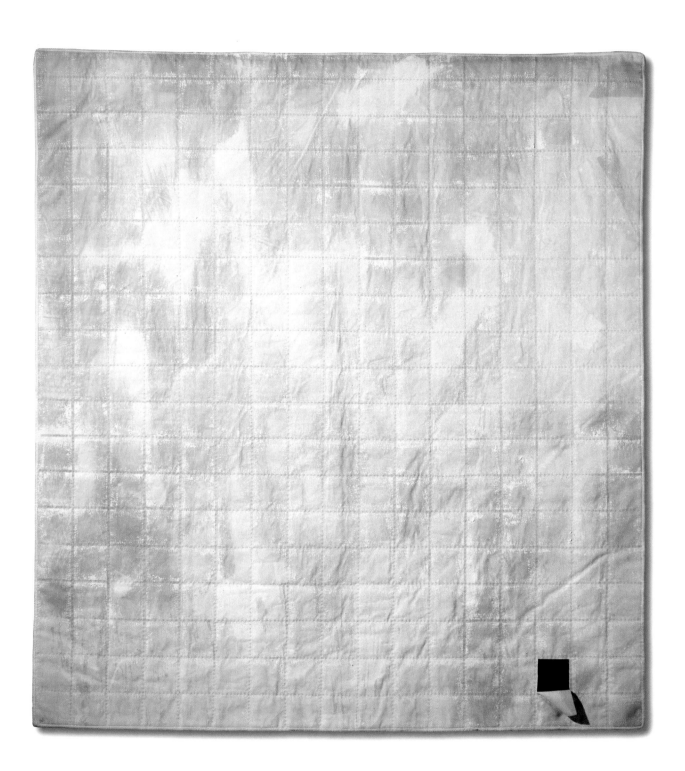

Bouillabaisse

22" x 43"

Diptych (2 squares)
Abstract Hand Painted
Masking Tape Resisted
Embroidered
Quilted
Hand Embellished

Meredyth Colberg

Fox River Grove, Illinois

Ever since that trip to Portland...I have been on a quest to experience the most flavorful Bouillabaisse. The benchmark for me...only the choicest and freshest ingredients and fresh fennel to enhance the broth.

A steamy, deep bowl of the stuff is like going deep sea fishin'. Each dip of the spoon is a pleasant surprise. You just never know what you will pull up. A delicate balance of flavors.

Like the art of creating Bouillabaisse...so too... the artistic process of the quilt. Starting with the freshest ingredients, a spontaneous painted surface design...hand and machine embellished in layers. Adding as you discern the need to fortify.. a dash of a motif for a pleasant surprise.

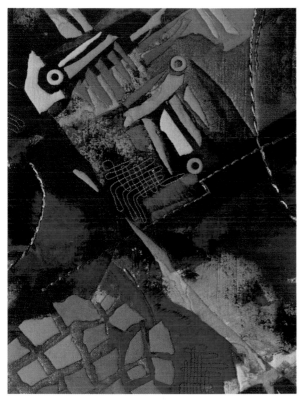

Detail

Close-up of complex painted surface.

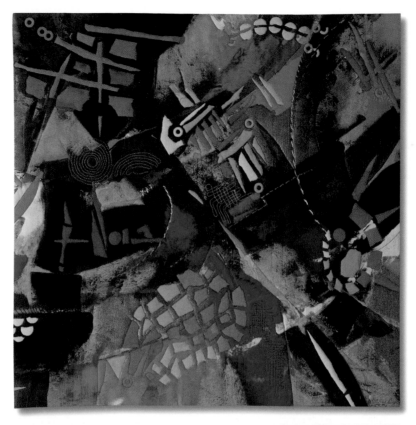

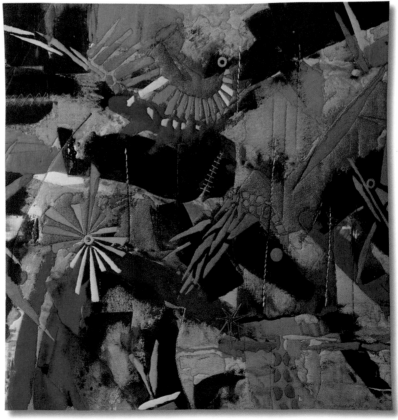

Marsh Light Series
"Eclipse"
58" x 52"

Judith Content

Palo Alto, California

Machine Pieced
Machine Quilted
Shibori Dyed
Discharged

The inspiration for my current work comes from the stark beauty of the mysterious, windswept marshes of the northern California coast. Vivid in the sun one moment, obscured by fog the next, marshes are an ever-changing landscape of evocative imagery, pattern, and texture.

"Eclipse" was inspired by a coastal climate phenomenon I recently read about. Under the right circumstances, a solar eclipse can create a sudden fog that lasts until the sun emerges from behind the moon.

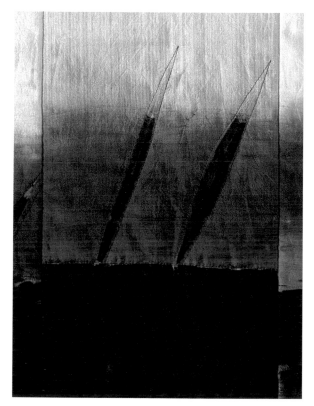

Detail

The fabrics are hand-dyed utilizing a contemporary interpretation of the traditional Japanese dye technique called *Arashi Shibori*. Panels of black pleated silk are submerged in a discharge solution to slowly remove the color from exposed areas of the silk.

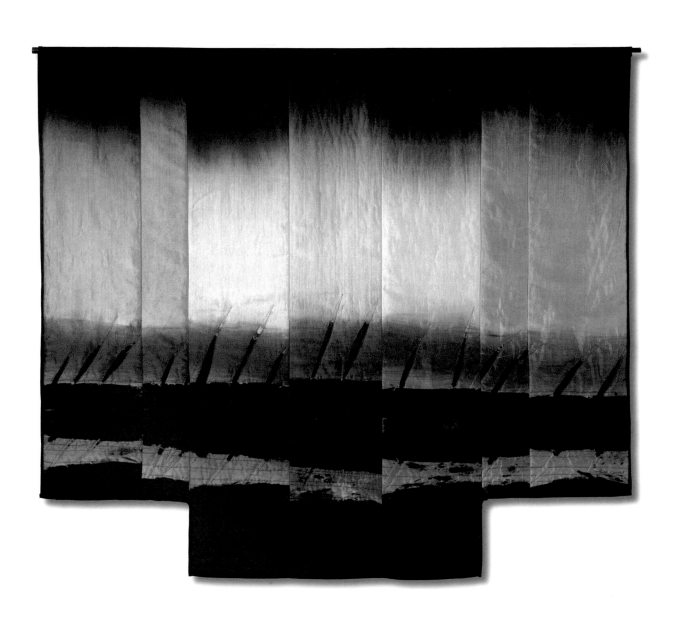

Down - and - Out Moon

40" x 33"

Machine Pieced
Direct Applique
Hand Embellished
Hand Quilted
Bias Strips
Bleached, Overpainted Fabric

Cindy Cooksey

Irvine, California

Years ago, I put a chain link fence in the foreground of a pen and ink drawing, so I challenged myself to do the same thing in a quilt. The similarities between the quilt and my old black and white drawing end with the fence. I wanted to create a more dramatic, dark mood in my quilt, with the night sky and ramshackle industrial buildings. Bits of bright color in the buildings, the starry sky and the oversize moon provide contrast. If there is any message, it would be that beauty can be found even in ordinary places.

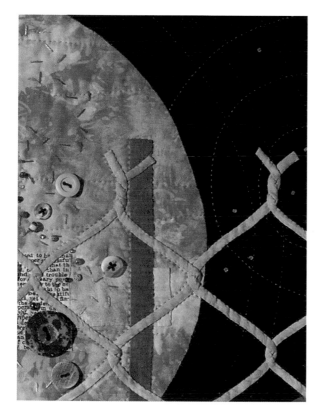

Detail

The fence was made using very thin bias strips of Bali cotton and appliqued down by hand.

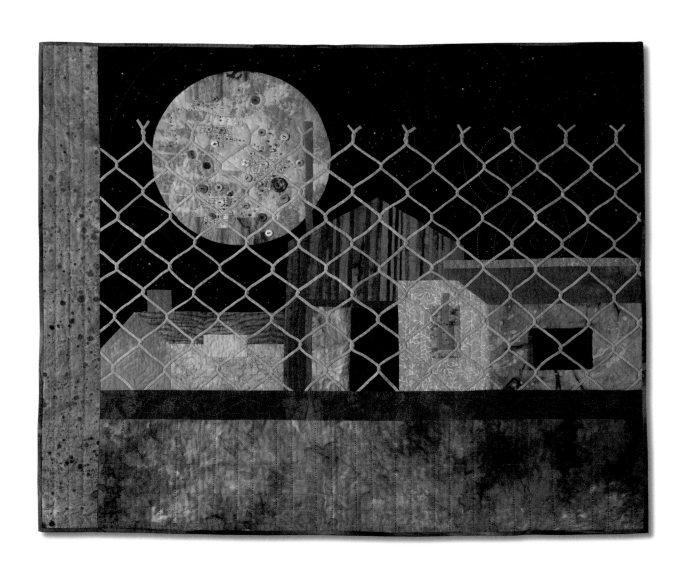

Two Sides to Every Story

Jane E. Dunnewold

44" x 56"

San Antonio , Texas

Hand Embellished
Hand Quilted
Laminated and Printed

I am interested in the interplay of layers - sheer fabrics, paper and paint - paired with light and shadow. Cutting squares and rectangles out of the batting makes the interactions even more complex. The title of the piece also alludes to our daily interactions, and indeed, to current world affairs.

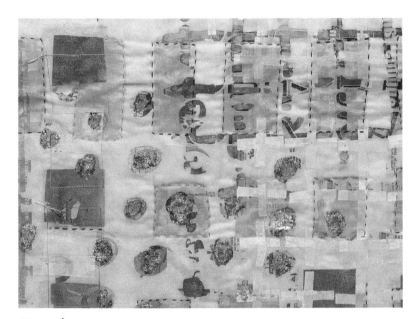

Detail

Two separate panels become back and front with batting in between.

Winner of the Quilts Japan Prize.

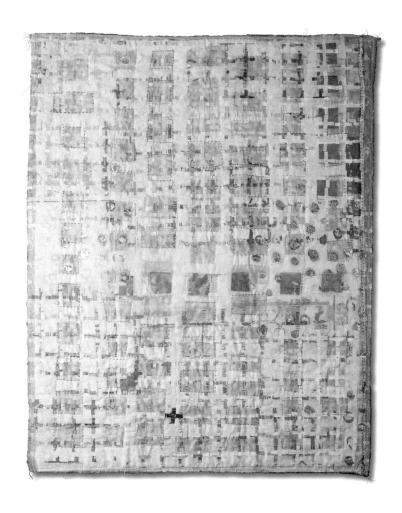

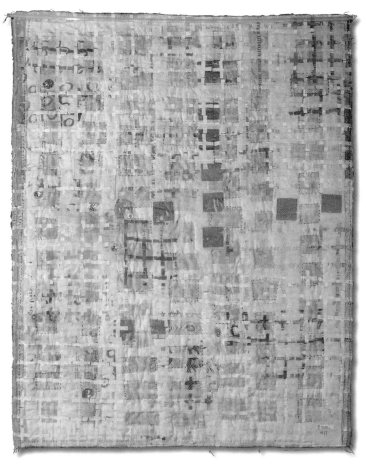

Nestled

Jane Einhorn

45" x 32"

Albuquerque, New Mexico

Machine Pieced
Machine Quilted

For me, working on "Nestled" was about those cheek-to-cheek snuggle times when the whole universe falls into a rhythm.

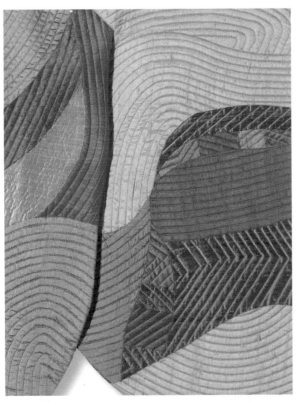

Detail

I love the work of art: cutting, sewing, piecing, and quilting the intensity of silks into shapes and rhythms.

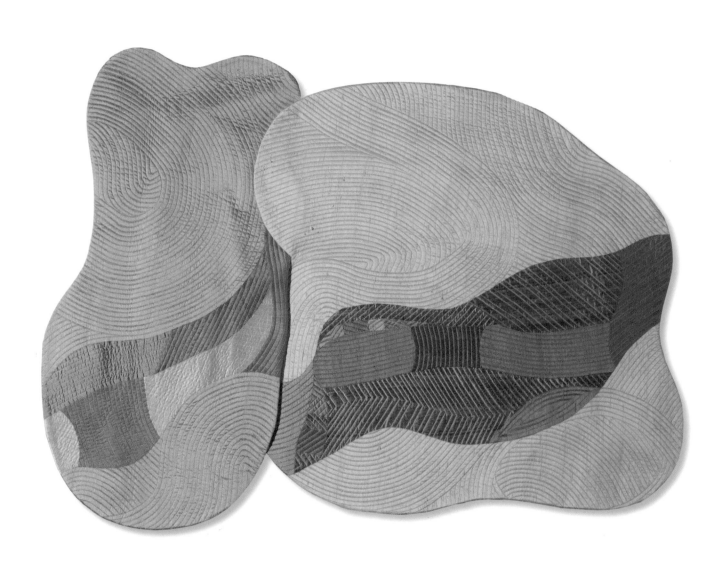

Nature In New Zealand

Noriko Endo

75" x 52"

Narashino, Chiba, Japan

Machine Embellished
Small Pieces Covered with Tulle

When visiting New Zealand, I was impressed by the beauty of Mother Nature. The sky was so clear and the land was diverse and colorful. The land called out to me. The verdant sweep of trees, the wet moss on the tree trunks inspired me to express this in a portrait of light and shadow. The changing light, reflection, and colors always excite me. A stroll into the woods with all of its color, light, splendor, and majesty adds to my well being.

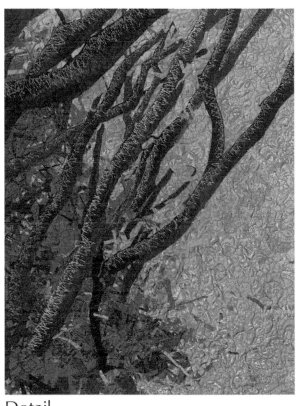

Detail

I cut fabrics in small pieces and put them on top of batting, covered with soft tulle net, then added quilting and embroidery.

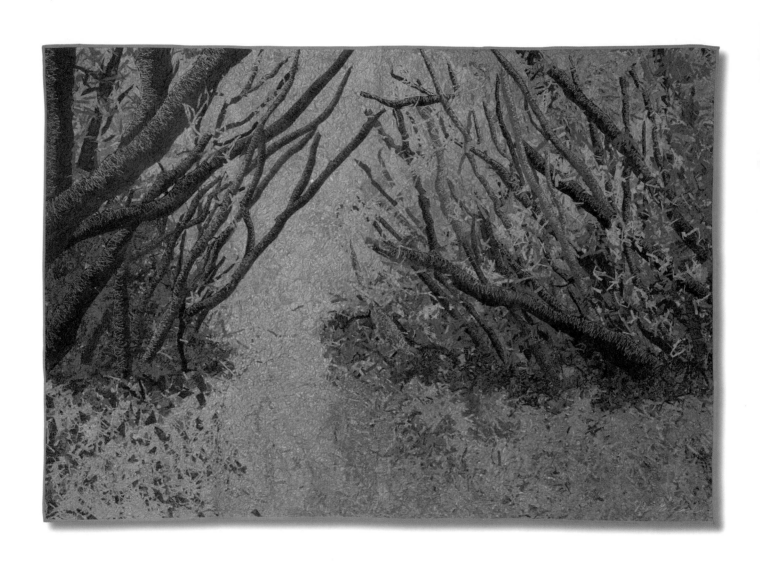

Sandstone Cloak

Pamela Fitzsimons

30" x 34"

Silks, Dyed with
Eucalyptus Leaves
Machine Pieced
Hand Quilted

Mount Vincent
New South Wales
Australia

Referring to the earliest Australian patch-work - the possum skin cloaks made by Aboriginal women. Silks, dyes with eucalyptus leaves and pieced together, produce a surface reminiscent of the sandstone walls of my house. the stitching process records the passing of time and echoes the cycles of nature.

Detail

Local plants provide the material used to dye fabrics, mostly silk; the colors are subtle, the process slow.

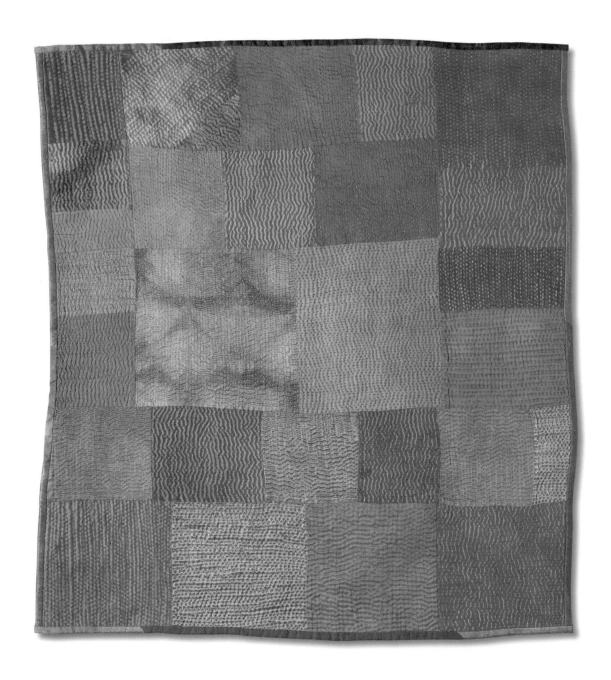

Darwinian Squares

62" x 62"

Machine Pieced
Machine Quilted

Dale Fleming
and
Dawn Guglielmino

Walnut Creek, California

The inspiration for this quilt was to celebrate the occasion of my husband's fiftieth birthday. My husband has admired Dale Fleming's unique approach to quilting especially her Darwinian designs, and has always wanted to own one of her quilts. The fact that Dale doesn't sell her quilts made ownership near impossible. Since we have known each other for a number of years, and have shared a passion for quilting, working on a quilt as a shared project was a natural.

The construction of the blocks is a process much like that of Darwin's process of Natural Selection. The blocks evolve over time, struggling for individual attention, while going through many modifications along the way. As one block is finished, the idea for the next starts, taking the features that we like and leaving behind the rest, "descent with modification," as Darwin would say.

Detail

This quilt was the work of two quilters with very different styles and color palettes...I leaned towards colors like olive and peach, she insisted on cheddar and lilac!

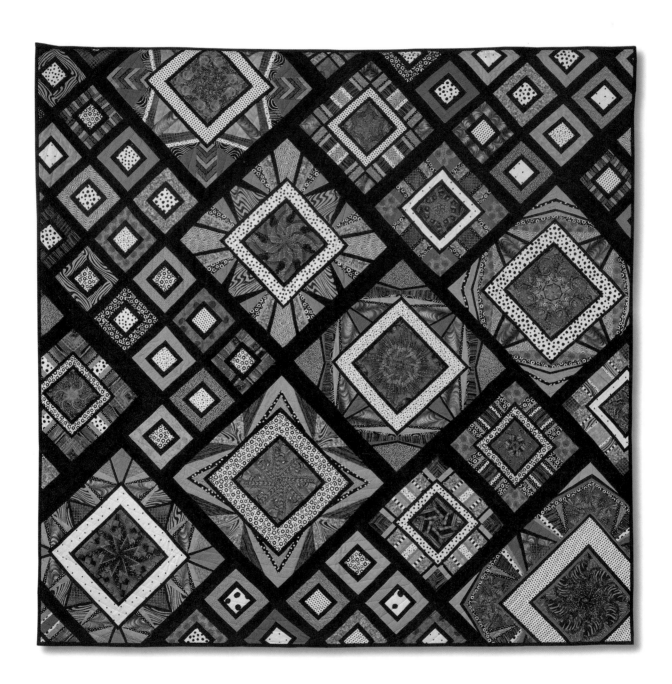

Winter Tree

Britt Friedman

27" x 34"

Oberlin, Ohio

Printed
Painted
Machine Pieced
Direct Applique
Machine Quilted

My quilts are meant to convey the excitement I feel about the natural world. Color, line, and form are used to write a kind of visual poetry describing that experience. This quilt is a part of a series in which I work not in real but imagined space - the space of the mind. The juxtaposition of images invites the viewer to create his or her own spatial interpretation of the different visual elements.

Detail

Printing and painting create the complex tree branches.

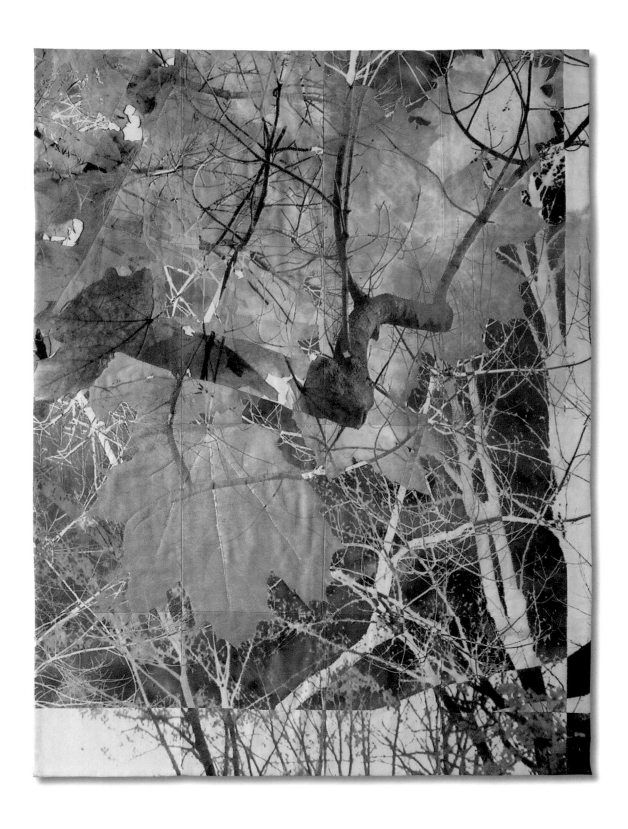

Polar Prowler

Particia M. Goffette

51" × 71"

Edmonds, Washington

Direct Applique
Machine Quilted

He roams the North Pole, usually alone, for months on end. Even though he looks intriguing, do keep your distance, or you will find out just what you are to him.

I used fabrics collected for many years from around the world. The quilt is entirely hand appliqued and machine quilted.

Detail

Free form shapes are basted to form the images and hand appliqued and machine quilted to suggest natural lines.

Winner of the Sponsor's Award.

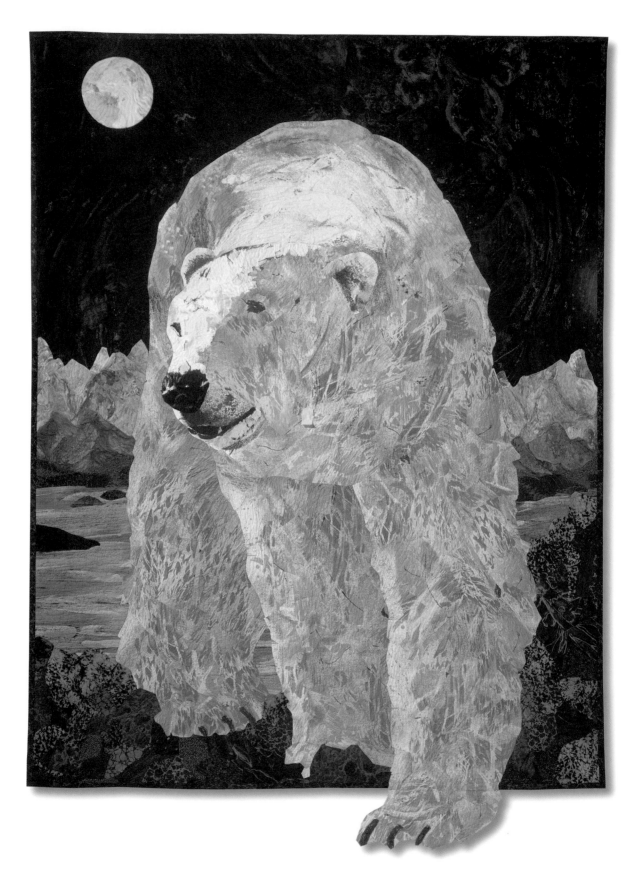

43

Party's Over

28" x 44"

Direct Applique
Machine Quilted
Textile Paints & Inks

Denise Tallon Havlan

Palos Hills, Illinois

At face value this quilt makes an obvious statement. When we look beyond the simplicity the image offers, it tells us more about the transition from childhood to adolescence. The physical and mental turmoil was memorable as the body fought the mind to move ahead. Looking deeper still the work takes on a stronger meaning when applied to the general state of affairs tackled through various stages of life. Personal, economical, social and political issues of the day have profound impact on our life and the lives of the ones that we love. Just when things seem to go smoothly, positive change is called upon to maintain normalcy. The endearing feature of this work is the fact that the child is my daughter. I watched with apprehension as she faced these hurdles from childhood to womanhood.

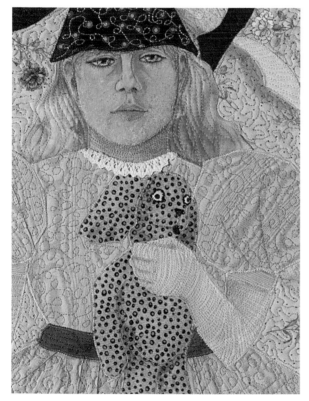

Detail

The images in my quilts most often portray historical and contemporary life. A moment of beauty, a perilous endeavor, both weaving their way into a picture of life. "Beauty with an edge."

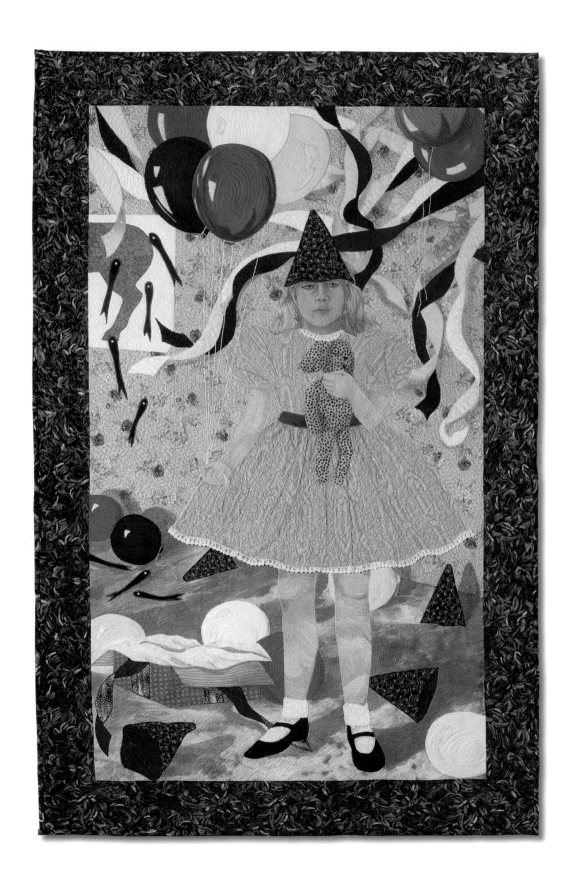

Stick Quilt

Lorre Hoffman

45" x 73"

Lander, Wyoming

Organza with Sticks for "Batting"
Machine Quilted

I used the quilting process in the "Stick Quilt" to use the reference to quilt as comfort and merge it with the idea of nest as home and together point to ideas of nesting. I often use natural elements in my work.

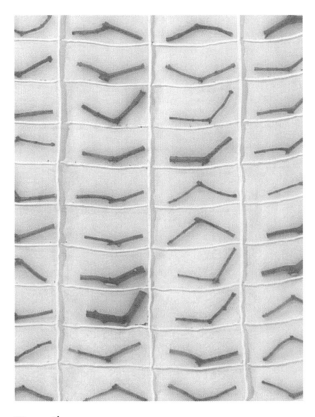

Detail

I have always loved sticks and how they look. The mark they make, that little curve they make where they branch at what is called the fork of the stick.

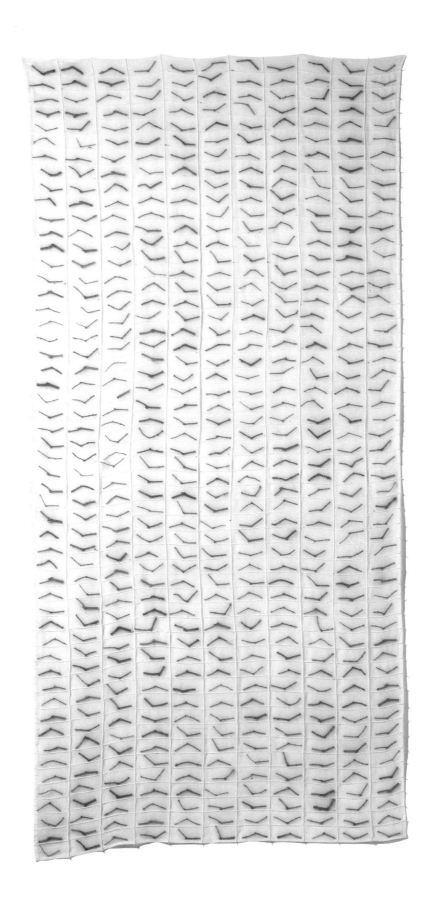

Save the Last Dance for Me

Wendy Huhn

44" x 68"

Dexter, Oregon

Hand Embellished
Machine Quilted
Airbrush
Imagery Transfers

If life is a job - then death must be the endless dance.

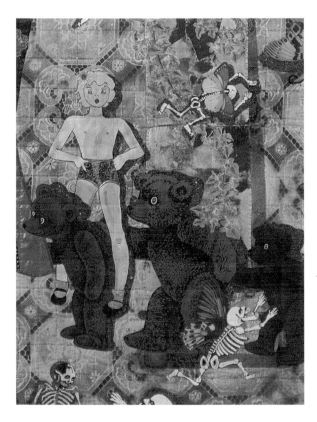

Detail

A variety of transfer images embellish the surface.

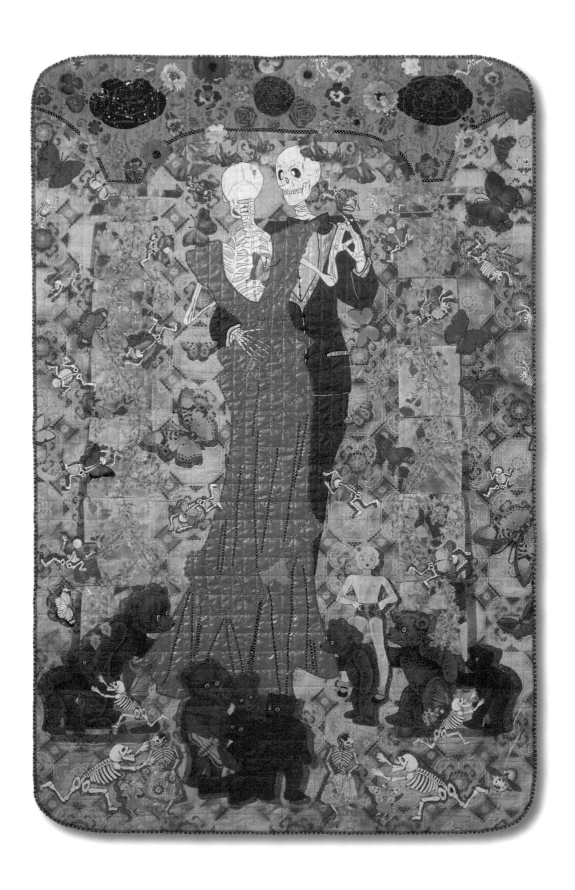

Foursquare Circles

Melody Johnson

52" x 52"

Cary, Illinois

Machine Quilted
Fused Applique

"Foursquare Circles" is the fourth in a series of experiments with strip fusing. I use fused fabrics to cut my strips and then assemble them in colorways, for example in this case, cool colors and warm colors. Then I add more thin slices of color on top of those colors. Finally I cut the circles from the blocks of color and transpose the cool with the warm to achieve my design. I am visually inspired by having multiple color interaction.

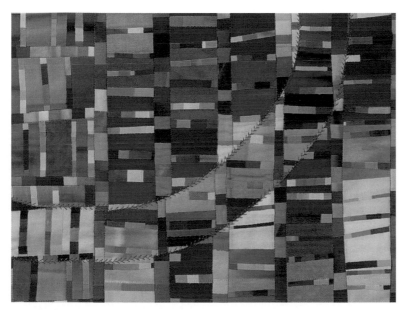

Detail

My version of strip piecing is all fused. I tried to use lighter values of cool colors so that the circle motif would be more subtle.

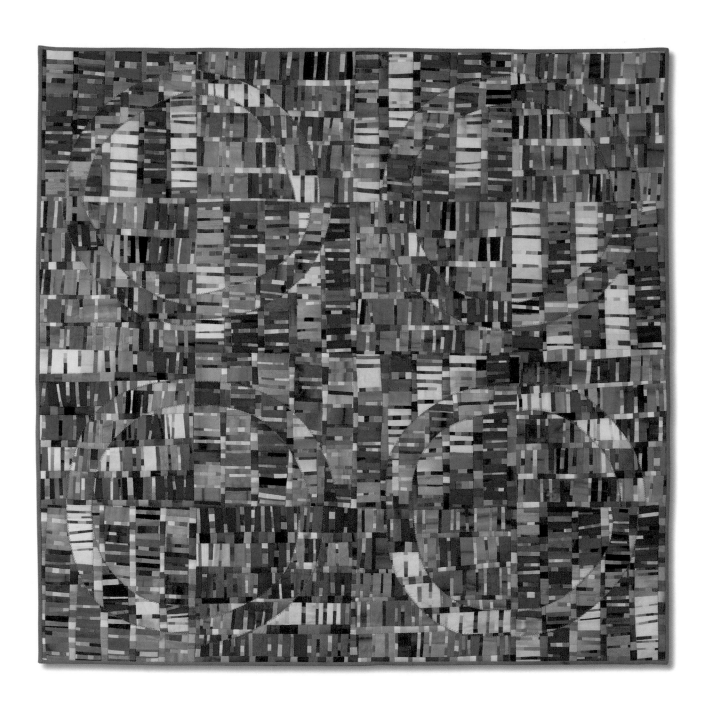

The Forest

Mi Sik Kim

81" x 83"

Non San, Choong Nam
South Korea

Hand Dyed Fabrics
Direct Applique
Reverse Applique
Hand Quilted

"The Forest" is work that expresses the scenery of Mt. Kyeyong. I live in the countryside near Mt Kyeyong, famous for the beautiful colors of each season. The autumn is especially beautiful. I love the changing color of leaves and every day the color is different, like painting and magic. The harmony of many different colors is amazing. I try to express those colors in my work, getting my designs from nature.

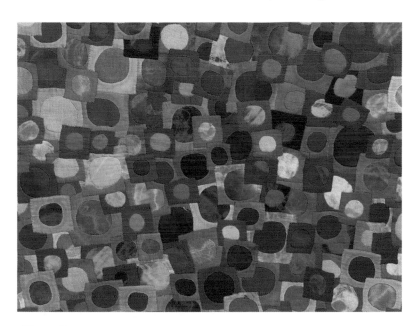

Detail

Many hand dyed fabrics are combined to evoke the natural world.

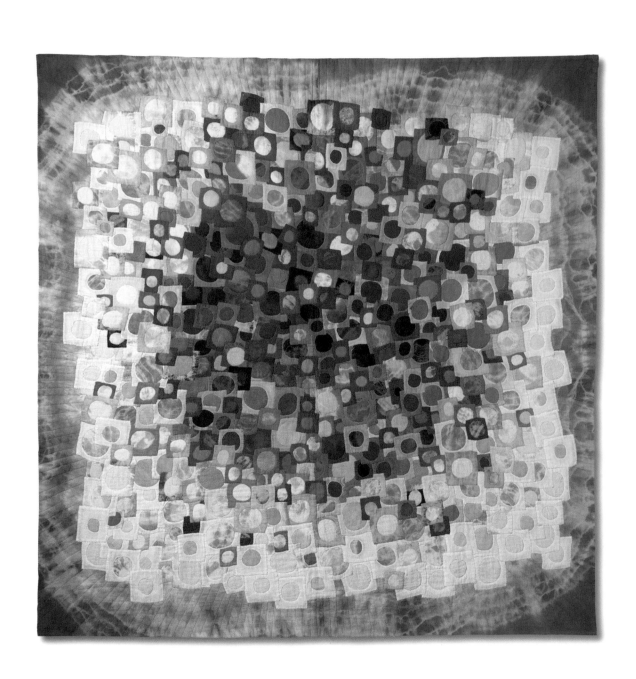

Lights

57.5" x 48.5"

Machine Pieced
Hand Quilted
Quilted by Knots in the Back of the
Work

Beatrice Lanter

Aeugst am Albis, Switzerland

Lights in the darkness always interested me. Light is hope. Light is warmth. Light is life. When I look down to a sleeping town in the night and I see all these lights shining, I feel the warmth, the liveliness which stays secret even in the darkness - and my imagination becomes colorful.

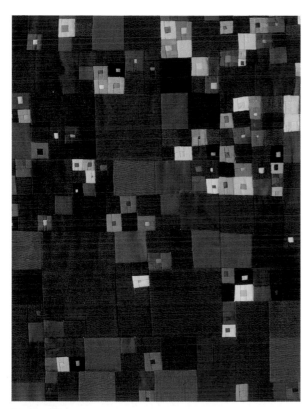

Detail

I can't get this old, traditional pattern "Log Cabin" off my mind. Again and again I am trying to find new variations like this.

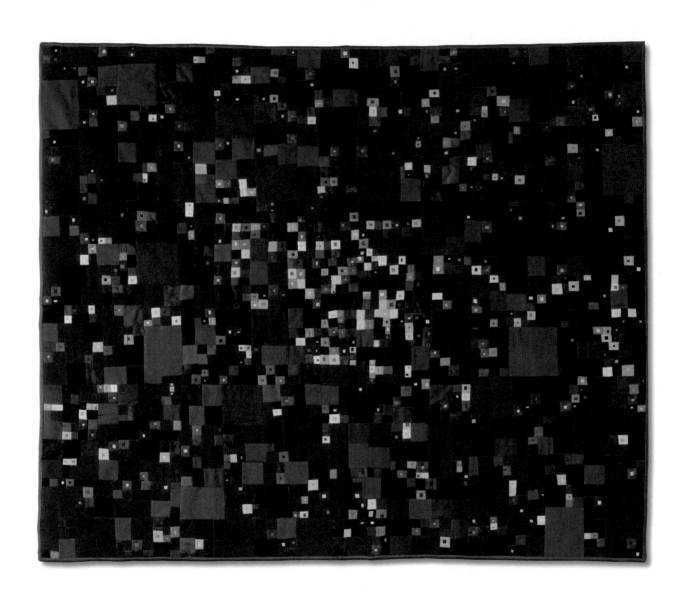

After Angkor

Robert Leathers

55" x 36"

La Jolla, California

Direct Applique
Machine Embellished
Machine Quilted
Hand Dyed Fabric
by Judy Robertson

Angkor Wat temple ruins in Cambodia are a study in man's attempt to control nature and nature's ability to eventually conquer.

My goal in this quilt is to capture the timeless struggle between man and the environment. That struggle is depicted by allusions to three-dimensional architectonic details and natural shapes. The forest invasion captures a romantic beauty that is a strange symbiosis between a manmade geometric order and a natural organic one.

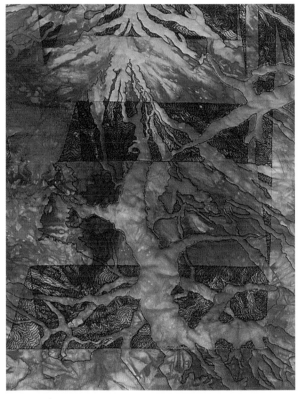

Detail

I have found that free-motion stitchery is an excellent medium for exploring these themes.

Winner of the CREAM Award.

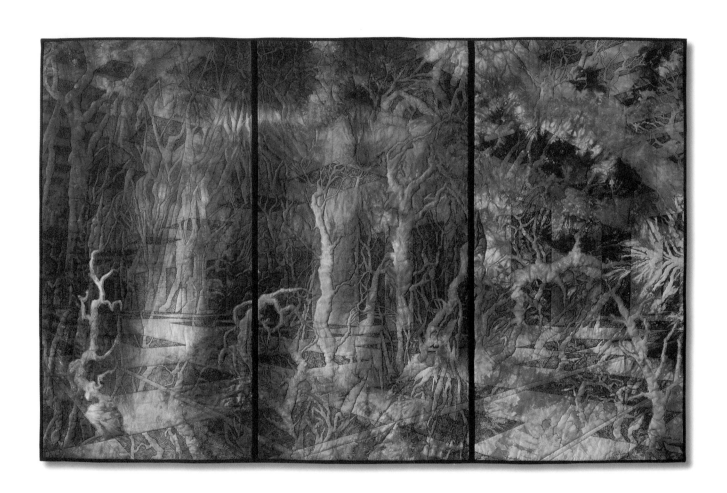

Monet Over Money

50" x 51"

Hand Embellished
Hand Quilted
Whole Cloth

John W. Lefelhocz

Athens, Ohio

Yeah, I don't get it either.

What makes a work of art valuable? Do you look at art differently when you see its' dollar value? Is art a commodity? Can the pursuit of money help or hurt the artist?

Yeah, I don't get it either.

I made this work for an auction to raise money for a local arts organization. It never made it to the auction.

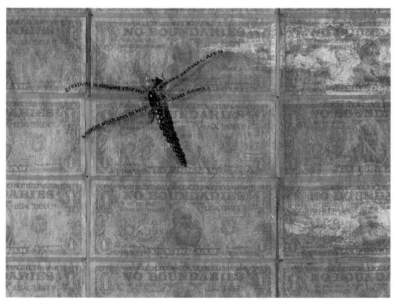

Detail

The dimensional dragonflies have moveable wings with shimmering messages.

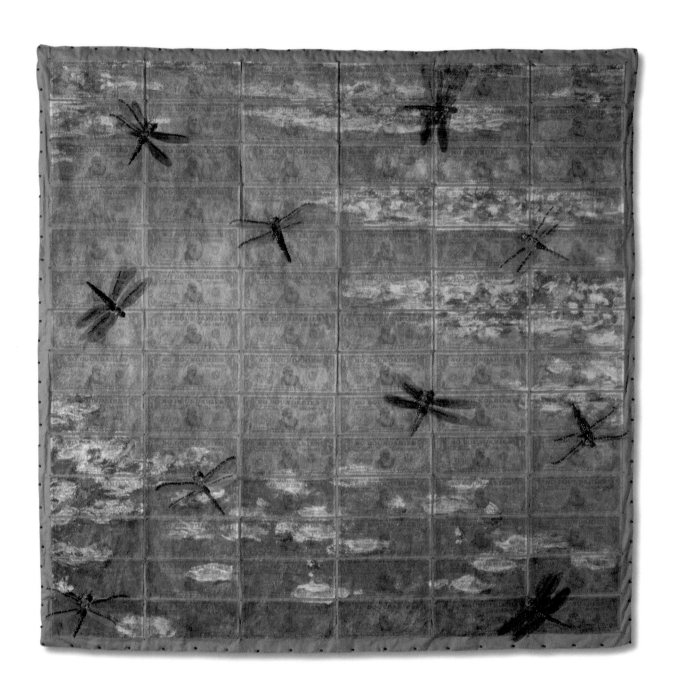

59

Aftermath

50" x 49"

Machine Pieced
Machine Quilted

Detail

Denise Linet

Center Harbor, New Hampshire

This piece was born out of my reaction to the events of September 2001. I am always fascinated by structures in various stages of de-construction; they emanate an energy, an aura and vitality from their previous existence. In the wake of September 11th the horror of the event was my motivation to document the remains of the World Trade Center's twin towers juxtaposed with other images of destruction. It was my intent to honor those lives who were so profoundly altered on that fateful day and to create a visual shrine dedicated to the soul of freedom, on an altar bloodied and wet with tears. This piece was created during a very emotionally charged time. As an artist, I needed to express my horror and grief. By working through this piece I was able to find my voice; no words or images could ever express the complete range of emotions this country went through in the days following 9-11. However, for me, it was important to express my personal response, to show that I cared about the victims, my country, and the threat to freedom around the world.

I have been using the copy machine to enlarge and distort photographs I have taken. These images are then transfered to fabric and incorporated into my work. The various methods include silkscreening, xerography, Polaroid transfer or direct printing using transfer paper.

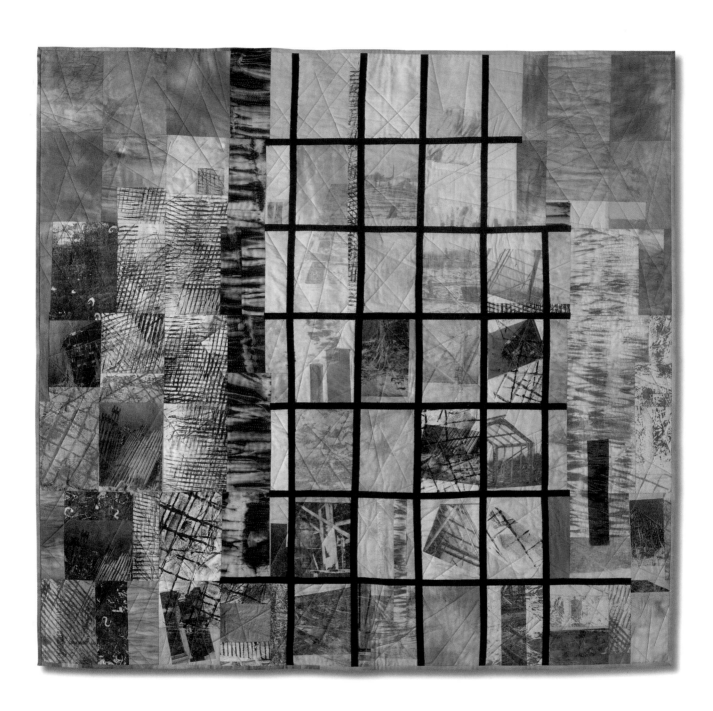

Landscape in Grey

Shulamit Liss

45" x 67"

Machine Pieced
Direct Applique
Hand Embellished
Machine Quilted

Yokneam-Moshava, Israel

On my way back home, in the late afternoon, from Tel-Hai where I instruct ArtQuilt, I drive along the Low Hills of Galilee. The sunset light paints the hill landscape in beautiful colors, which alters from gray to red and to black. The soft shape of the hills and the change of colors have provided me the inspiration. " Landscape in Grey "was the first work in the landscape series. In this quilt, I want to convey the feeling and the atmosphere of the fading light and landscape in an abstract expression.

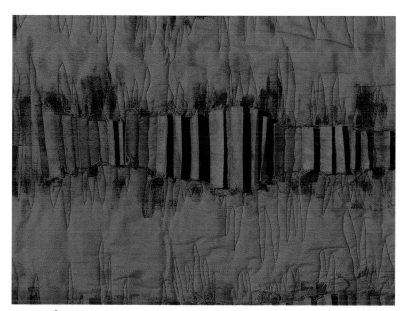

Detail

Dimensional techniques give the surface greater interest.

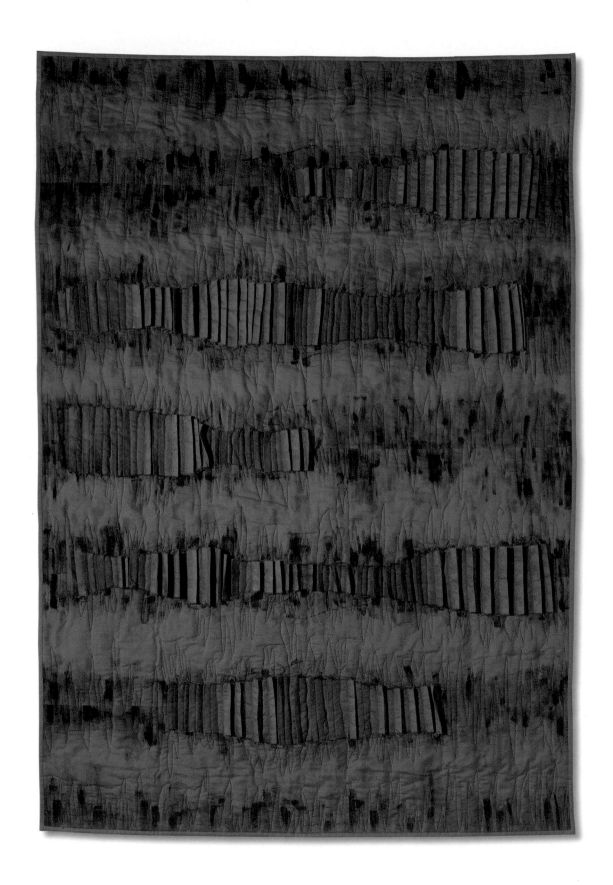

Stumps To The City

Linda MacDonald

42" x 34"

Hand Quilted
Whole Top - Painted

Willits, California

My work is about living in northern California and seeing and recording the changes that are occurring due to population, livelihood, and natural events and disasters. Logging has changed the environment drastically. All of the old growth trees are gone except for the few in national parks. The economy of logging towns fail as large companies log off the leftover forests with state - of - the - art equipment. What is left is chipped up and used to make waferboard. The logger migrates to an urban area. In this piece, the trees have created the urban environment.

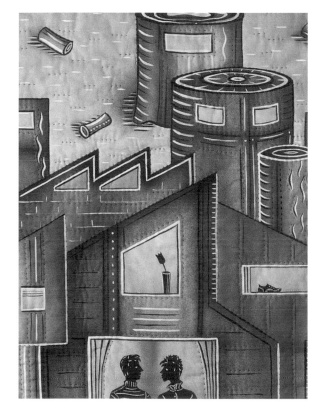

Detail

My process in creating this piece is to start with a small drawing that is complete. I project it onto freezer paper. The freezer paper "pattern" becomes a stencil to use in airbrushing the images on my painting wall.

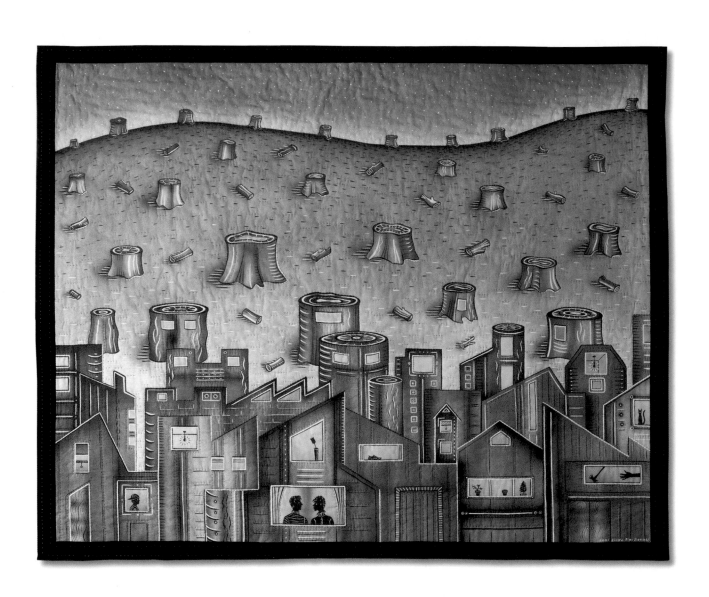

Crow's Nest II

Inge Mardal & Steen Hougs

41" x 53"

Brussels, Belgium

Machine Quilted
Hand Painted

Magnificently suspended in an early spring treetop this crow's condo at pent house level outbeats anything constructed by man.

The inspiration for this quilt is founded in the admiration of the elegant lines of a tall tree on our Brussels neighborhood and a pair of crows' ability to establish their new home in the treetop.

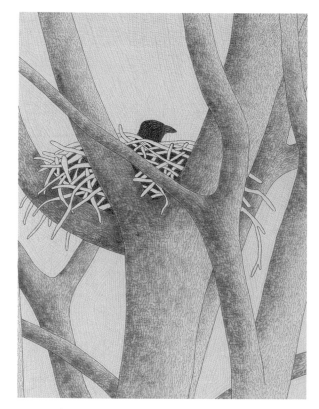

Detail

In this whole-cloth reduced size quilt, the thread plays the major role in the process of quilting and colour is applied sparsely.

Winner of the President's Choice Award.

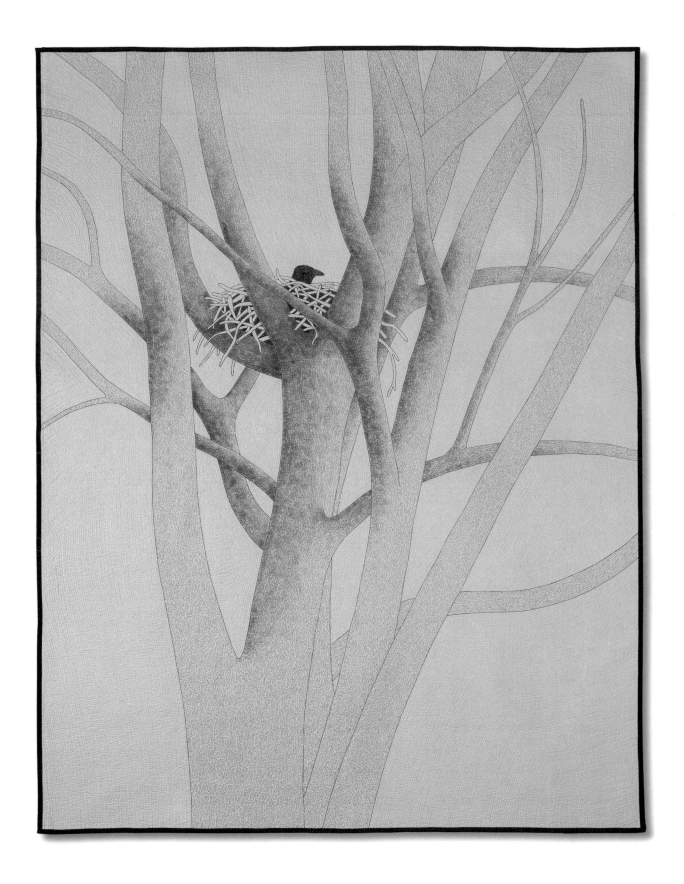

Eva's Night Out

48" x 76"

Machine Pieced
Hand Embellished
Hand Quilted

Lori Mason

Portland, Oregon

This is a commemorative quilt made from my grandmother's collection of silk scarves.

"Eva's Night Out" is made from a shoebox full of silk scarves that belonged to my grandmother. It is a commemorative quilt - the fourth in a series that I have constructed out of her clothing. I wanted to make a quilt that expressed her vibrancy and energy and zest for life.

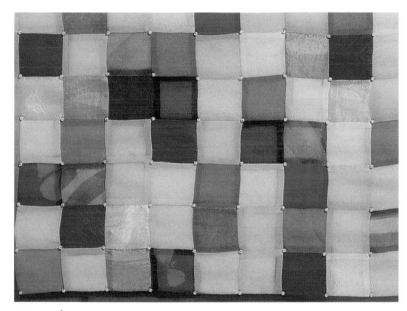

Detail

Pearls secure the intersections.

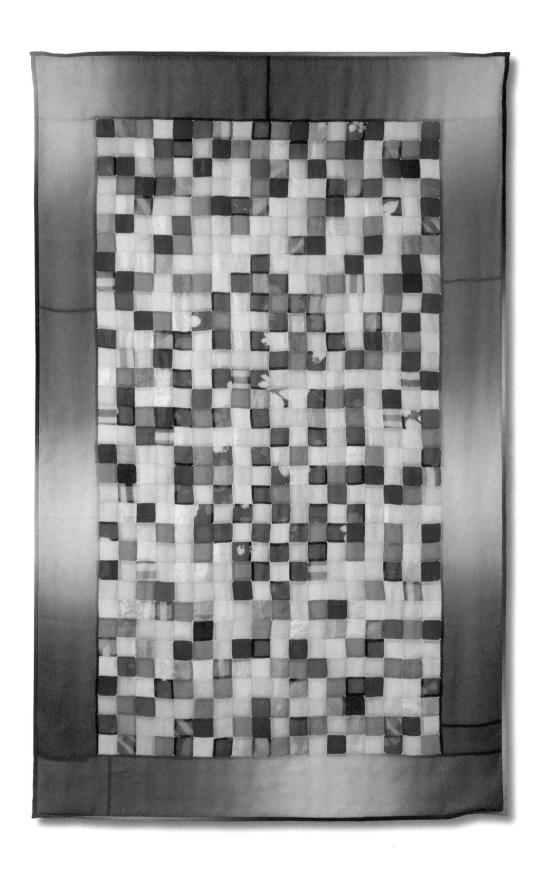

69

Moss

85" x 85"

Machine Pieced
Machine Quilted

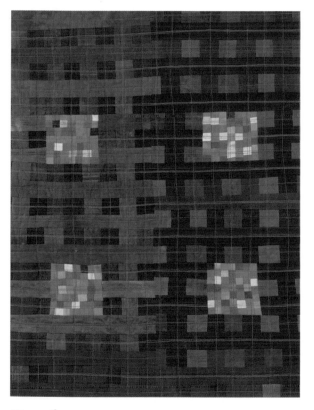

Detail

Eleanor McCain

Shalimar, Florida

This quilt is not about the following:

my breasts, my vagina, my menstrual
periods
sexuality
sexual politics
sexism
racism
rape
victims
Oklahoma City
the Holocaust
September 11
guns or gun control
animal rights
spirituality
healing
auras
astral planes
karma
the goddess within
the inner child
the Venus of Willendorf
nature
chocolate addiciton
the rain forest
whales
baby seals
menopause

Simple squares are used to create a complex design.

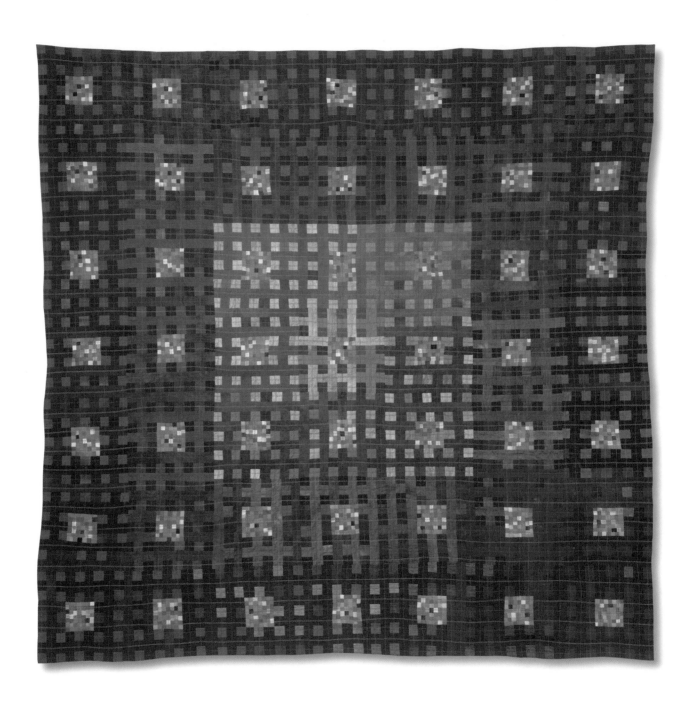

100 Treasures

98" x 98"

Machine Pieced
Direct Applique
Machine Quilted

Karen Miller

Corvallis, Oregon

The Japanese dye fabrics with hand cut paper stencils, used to apply a rice paste resist, a process known as kaktzome. I adore them for the virtuosity of their carving, the variety of their patterns and for what they reveal of the deep respect of the Japanese artists for their own native plants and animals. This is a feeling I share, having been trained as a marine biologist. I began cutting stencils in 1995. The many traditional patterns I have carved have been a "do-it-myself" apprenticeship. I find it simultaneously relaxing and exacting, traditional and yet enormously flexible as a surface design tool. I started these small stencils in early 2001 at a time of great stress, partly to help me relax, and it was like eating salted peanuts. The result is this indigo dyed collection, quilted in a pattern known as "seven treasures," hence its' name.

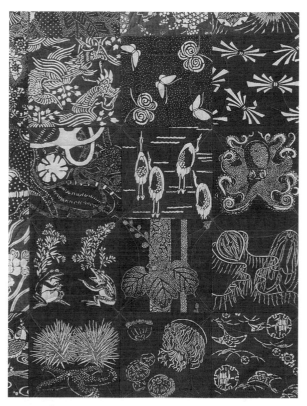

Detail

Included are several of my original stencil designs of marine animals, sea anemones, jellyfish, comb jellies, brittle stars and sea urchins.

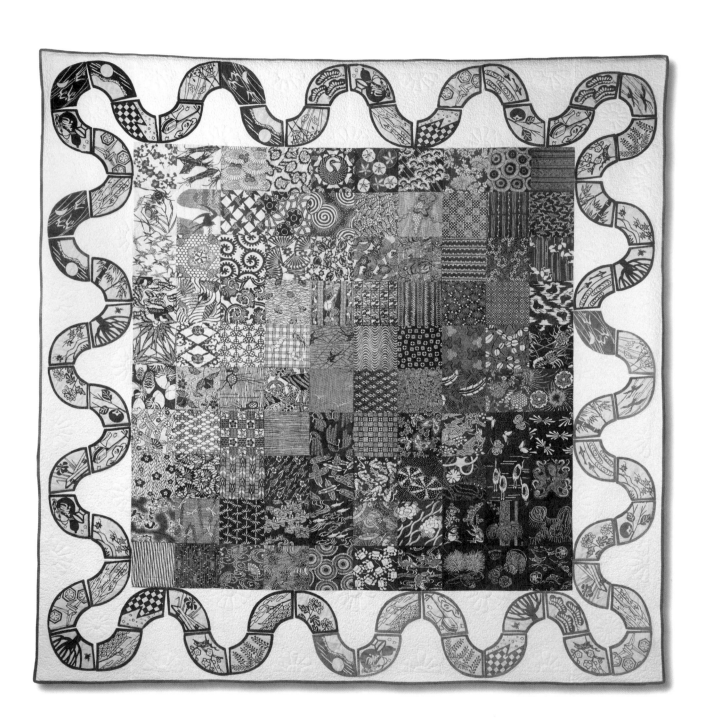

73

Cut Out To Be A Good Wife

30" x 36"

Machine Pieced
Machine Quilted
Color Photo Transfer

Cynthia Myerberg

Morgantown, West Virginia

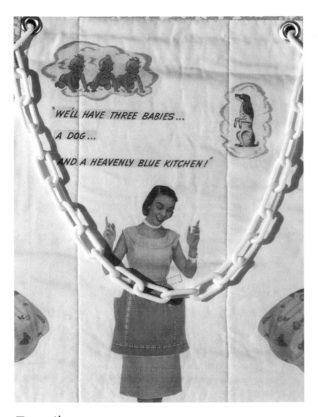

Detail

Plastic chains are used for the apron strings and provide another dimension.

Images of women, as they were constructed by the male dominated mass-media, provide subject matter for my *Kitchen Help* apron series. These images, as well as ads and editorials, shaped the way that women saw themselves.

"Cut Out To Be A Good Wife" looks at the post-World War II media propaganda campaign to get women out of the work force and back to their proper place, the home.

Fueled by the fears that there would not be enough jobs for returning servicemen and that another depression might ensue, four million women were fired from their "war jobs" in 1946. Women's publications, like *Good Housekeeping, Ladies Home Journal, McCall's*, and *Woman's Day* extolled the virtues of marriage, family, and the future dream home and became manuals for "how to get a husband" and/or "how to be a good wife."

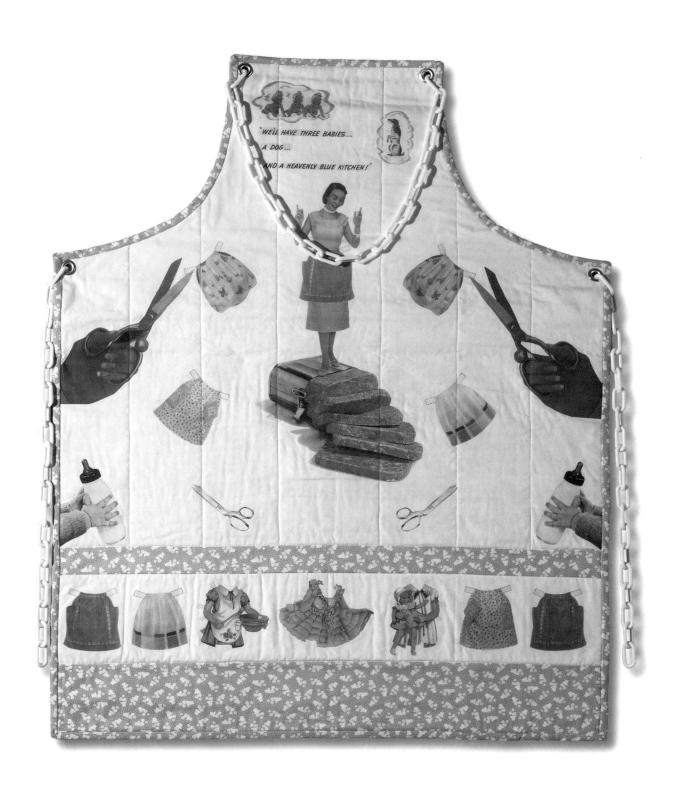

Jarred Memory III

Jacquelyn R. Nouveau

31" x 26"

Direct Applique
Hand Quilted
Machine Quilted

Chapel Hill, North Carolina

A sound, a smell, an incident or other stimuli will do what is known as "jarring a memory." The phrase recalled memories of my mother preserving fruits, vegetables, even venison in those days before freezing those items was practical. Lined up in a row on a shelf, they were memories of the bounties and energy of the past season. I began to envision some of my memories preserved in jars. A tree perched on a cliff from a trip to Bryce Canyon was placed in a jar, thread painted then draped with ethereal images of multiple jars waiting to be filled and preserved with other memories.

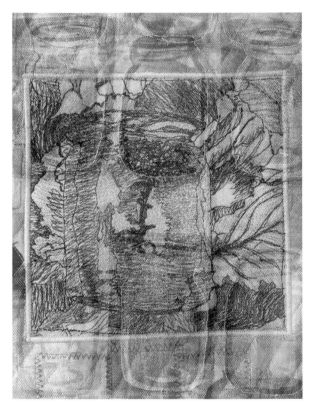

Detail

Close-up of thread painting seen through a "mist" of screen printed netting.

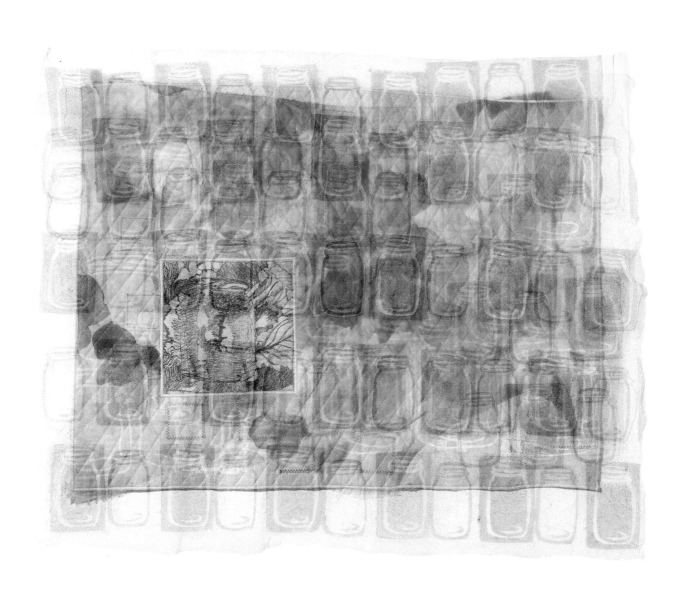

Potamogeton

Elsbeth Nusser - Lampe

30" x 40"

Freiburg, Germany

Machine Pieced
Direct Applique
Machine Quilted
Machine Embroidery

In summertime when you are walking along a stream, you can notice a wonderful scene in the water. The running water moves a dense wood of luxurious plants very slowly. When the sunlight is broken at the surface, a wonderful atmosphere appears. This is the inspiration for my quilt "Potamogeton." The title of the work relates to the Latin name of this special group of plants in the water - Potamogeton.

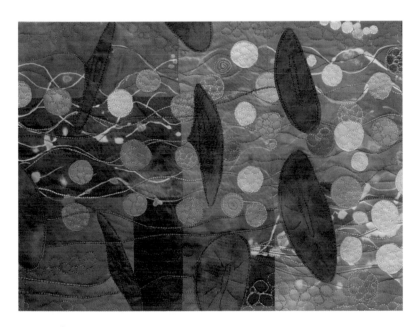

Detail

Close-up of the complex surface enhanced by stitching.

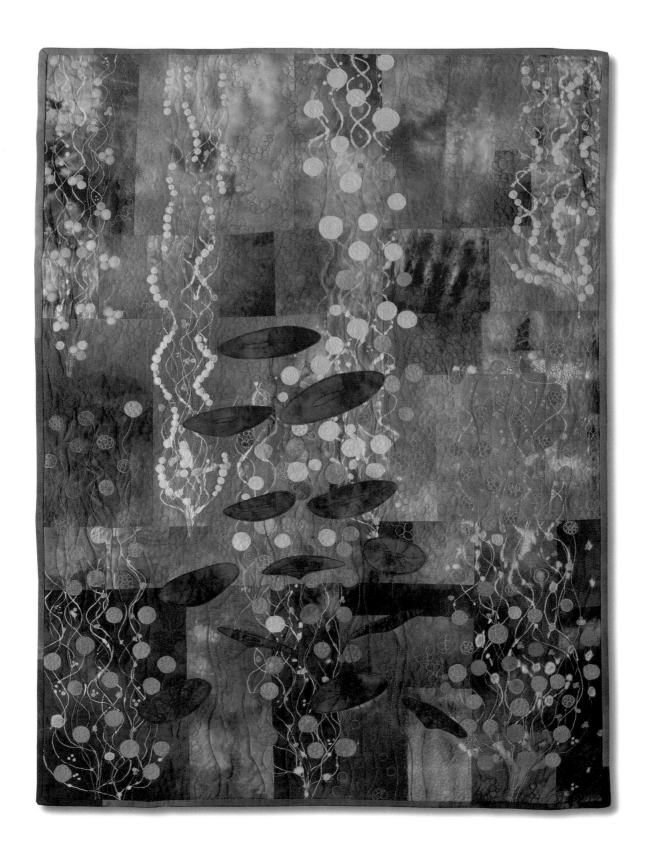

"FG Block ECB"

75" x 75"

Machine Pieced
Silk Screen Printing
Machine Quilted

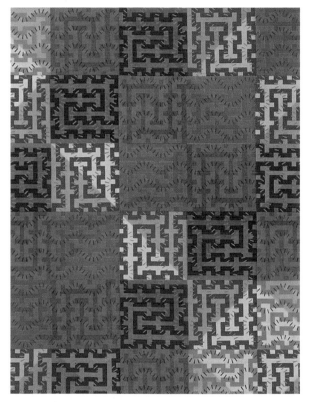

Detail

Close- up of screen printing.

Ellen Oppenheimer

Oakland, California

"FG Block ECB" is the second quilt that I have finished in a series of quilts for beds. This series of quilts is a response to rising energy costs, diminishing storage space and a dearth of clients interested in purchasing my quilts - the logical course of action was to start to make quilts for the bed. The "Block" series was initially inspired by a concrete block wall that I spent a long time staring at in a somewhat delirious state of mind. These quilts are composed of a series of 7.5" square blocks that are created by printing several different patterns in both dyes and inks on a piece of fabric. I start the process with drawings on the computer, which I develop into silkscreens. Although the computer allows me to experiment with many different colors and layering possibilities, I have found that the computer drawings do not easily describe the results that I will achieve with fabric and inks. I make several small studies with different screens and dyes to determine pattern variables and colors. I work the most promising studies into large quilts.

FG stands for "Flying Goose" which of course refers to the repeated triangles. ECB is for Ellen and Carol's bed.

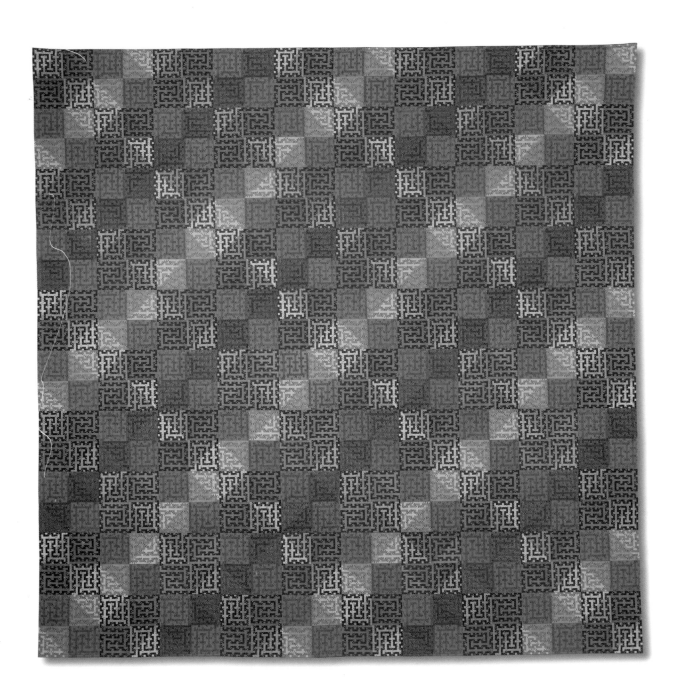

Touch Tone Dilemma

Charlotte Patera

54" x 50"

Grass Valley, California

Machine Pieced
Direct Applique
Reverse Applique
Machine Quilted
Computer Printed Fabric

Who in the civilized world has not known the frustration of the automated answering machine, voice mail, with a menu of options that do not apply to your call and with no human being available? I began making elements for this quilt with no idea of how to put them together. When viewing the wreckage of the World Trade Center attack, I suddenly started to work fast and furiously to create this chaos. The quilt became a catharsis for my feelings of anger and shock. It became more than just dismay over a trivial phone call but more like "What is happening to the world?"

Detail
Close up printed fabric.

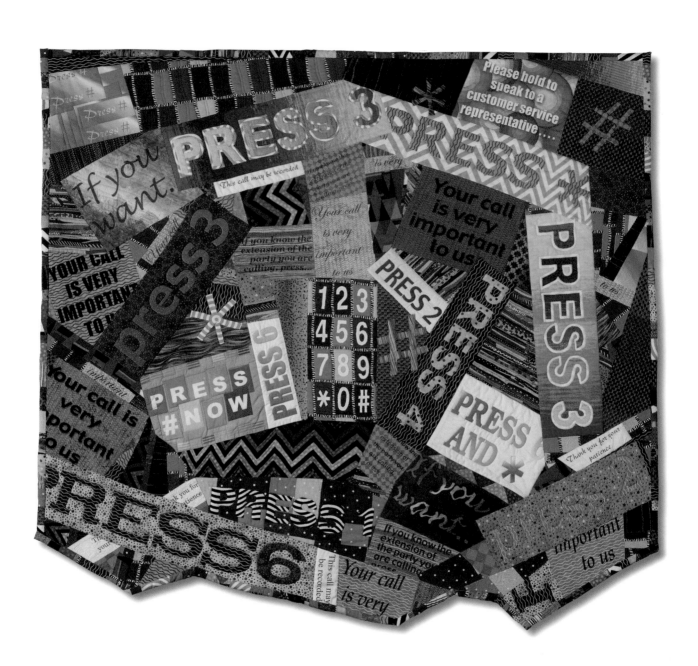

Flag Waving On The Home Front
60" x 72"

Direct Applique
Machine Embellished
Machine Quilted

Sue Pierce

Rockville, Maryland

I collect vintage kitchen textiles, valuing the history they have witnessed as well as the association with women's work. I use fragments, elevating them to the status museums accord the remnant of some ancient tapestry. This work was begun last summer, with no title. After September 11th, the piece assumed a new meaning. The flags represented the true blue patriotic efforts that burst forth across our country. Households of every background joined in the unity of a common voice, while still responding in unique ways. As I completed the last section, it became clear that the focus was on issues of diversity and unity, which can indeed coexist both in art and real life. In America, we are free to express our opinions and each do so with our own individual and distinct vocabulary of words or images.

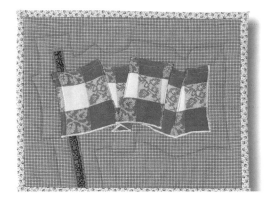

Detail

Each "flag" is a separate small quilt.

Winner of the Williamson Family Memorial Award.

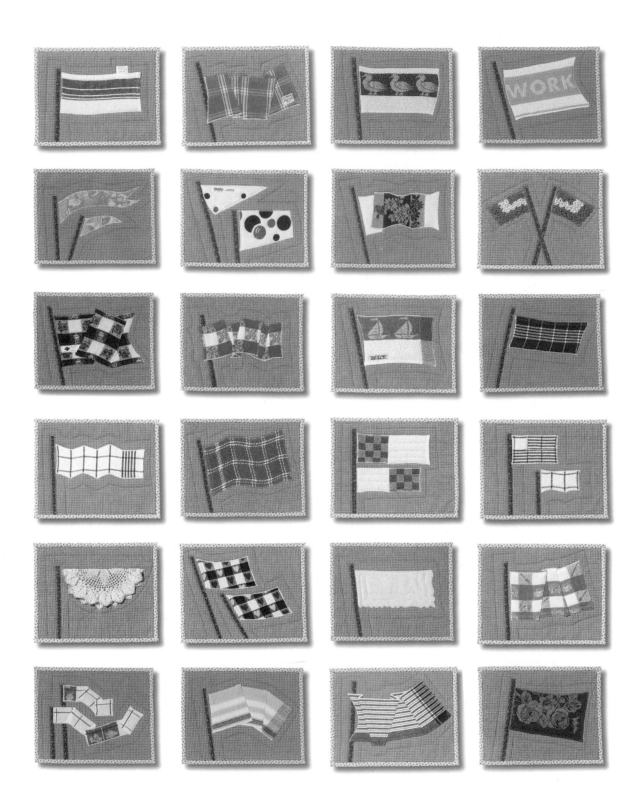

Gravity Girl has a Dream

Dinah Sargeant

41" x 41"

Newhall, California

Hand Pieced
Machine Pieced
Direct Applique
Reverse Applique
Hand Quilted
Machine Quilted
Hand Painted Fabric by Artist

Last year a woman left this world after a long illness. I thought about her spirit often, the release of her spirit, and was surprised by her presence as she traveled through strangers, in glimpses, held here by the pull of heart and memory.

Detail

The application of shapes is direct and collage-like, with machine piecing, applique, and hand and machine quilting.

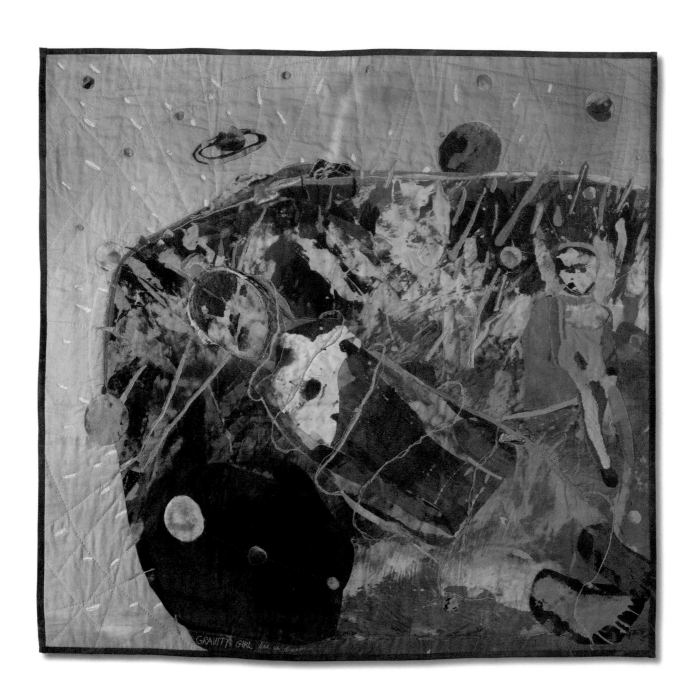

Deciduous

Connie Scheele

50" x 50"

Machine Pieced
Hand Quilted

Houston, Texas

A continuation and variation in a series of quilts about river rocks and grasses, this one deals with deciduous leaves. In an effort to merely suggest that these forms are leaves, simple lines and shapes were used. The palette of hand dyed fabrics is in autumn colors and fine lines were hand painted to add texture to the forms.

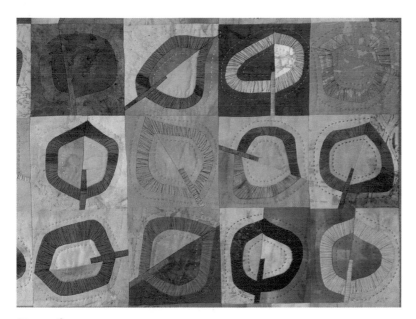

Detail

I am particularly fascinated by complex curves and their relationship to straight lines.

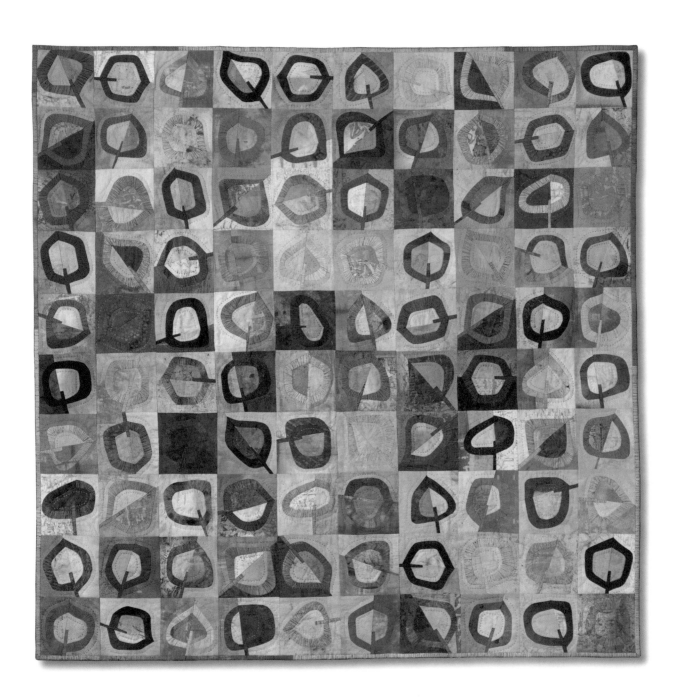

89

Color Squares 1

56" x 56"

Machine Pieced
Direct Applique
Machine Embellished
Machine Quilted

Carol Schepps

Princeton JCT, New Jersey

"Color Squares 1" was created at the end of September 2001. The homespun look of the Luminary ® fabrics was very comforting. All my work previous to "Color Squares 1" is rectangular or is framed; I purposely let go of those rules with "Color Squares 1. " The lines and borders wobble but the piece lies flat. Sometimes it's good to let go of the rules and step out of the self-imposed box. After September 11th, it seemed that all the rules and details of everyday life weren't as critical. I know it's not much, but this was about as loose as I could get: easygoing, warm, nothing fitting too closely or strictly.

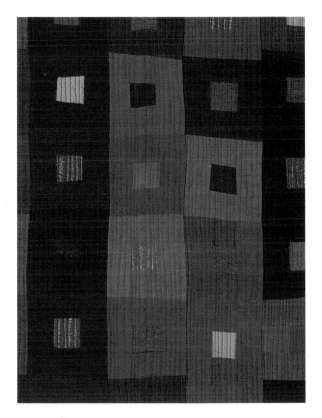

Detail

Cotton and cotton/nylon blend fabrics have been combined.

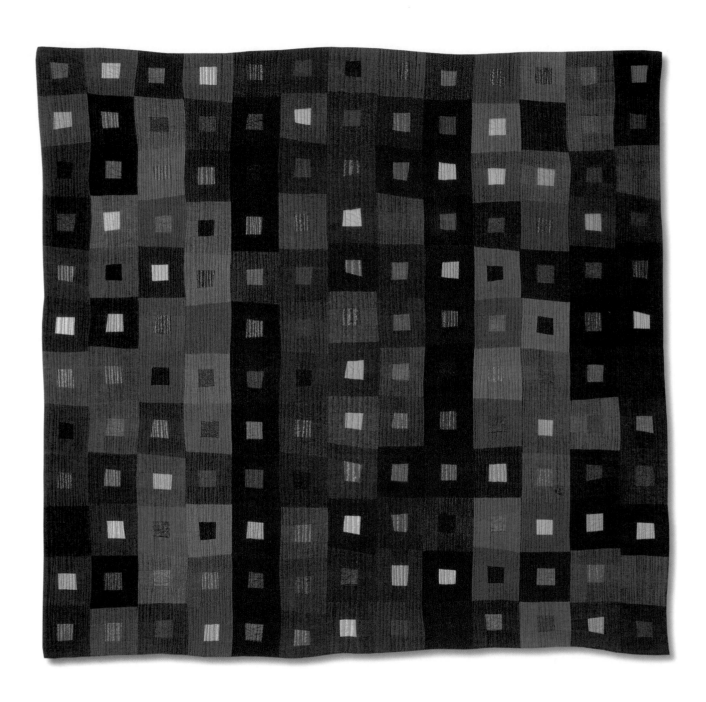

Red Birds Nest

42" x 42"

Machine Pieced
Direct Applique
Machine Quilted

Fran Skiles

Plantation, Florida

My quilts depict a sense of place, an imaginary landscape, so to speak. I delight in discovering new ways to use materials, and by using fabric and paper so that they are undistinguishable from one another. I invite the viewer to discover his or her own interpretation of "Red Birds Nest."

Detail

Close-up of the bird.

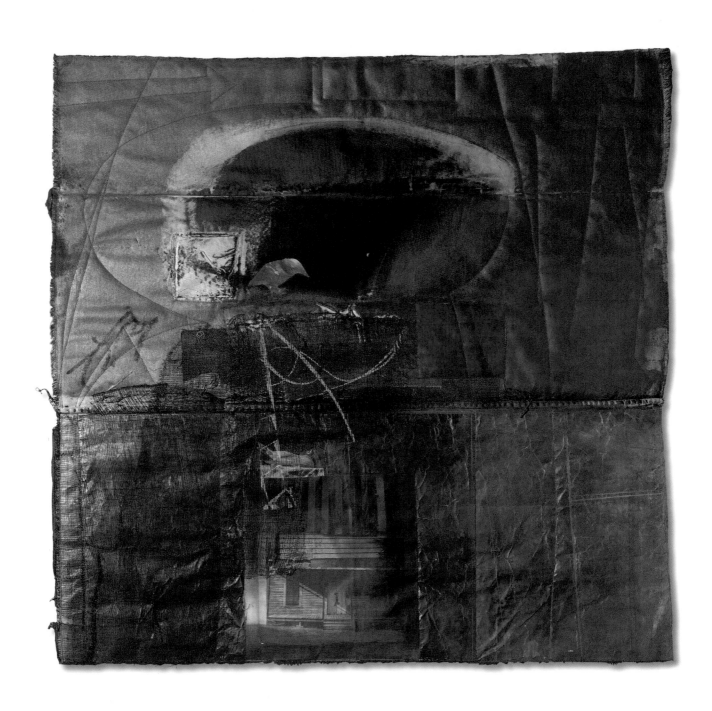

Left Turn Lane #15

Thelma Smith

52" x 82"

Green Valley, Arizona

Machine Quilted
Whole Cloth
Dye Painted

This work was painted and batted up before the madness of 9/11. Yet it is strangely prophetic. It is well to be mindful of how blatant we are in our wealth, how blatant we are in our waste. We need to consider how wealthy even the very poorest among us is, when considered on the worldly scale of things.
We need to look, to see, and to honor the fact that, in spite of the trappings or the lack of them, we are all human beings who want to be happy and not to suffer.

Detail

Close-up of dye painted details.

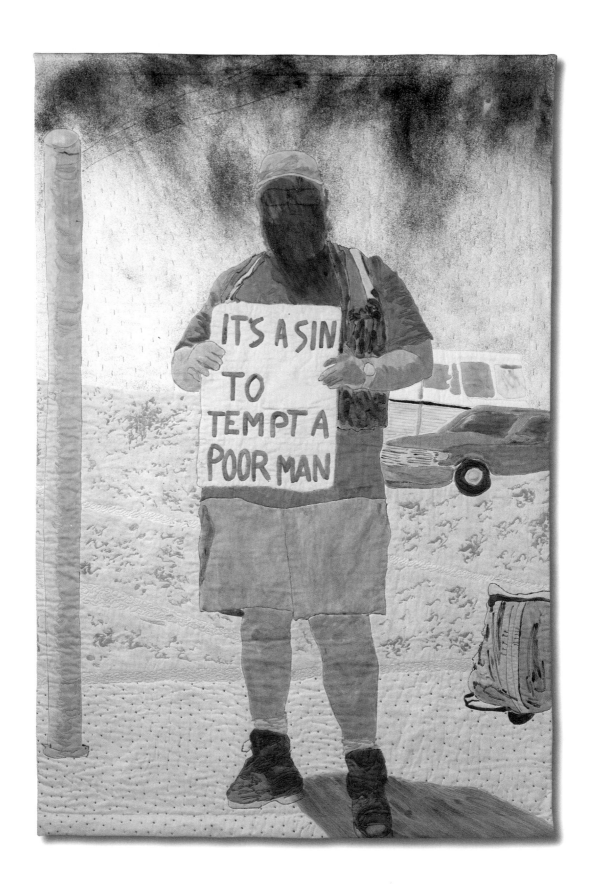

Salmon Flash

Nelda Warkentin

48" x 60"

Anchorage, Alaska

Machine Pieced
Machine Quilted
Multiple Layers of Acrylic Painted
Transparent Silk Over Cotton and
Linen.

I use line, pattern and color to express a memory, mood, or idea. I construct my quilts in squares, as I use the lines created by the seams to convey balance and order. My work is about rhythm and symmetry.

"Salmon Flash" is second in a series of 4' x 5' quilts. Multiple layers of acrylic-painted transparent silk allow the viewer to see through the surface to the stitching and colors underneath. Colorful machine quilting enhances the design.

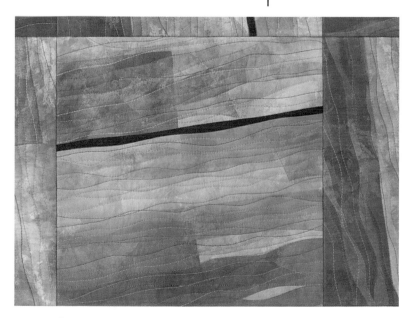

Detail

Stitching creates additional "movement "on the surface of the quilt.

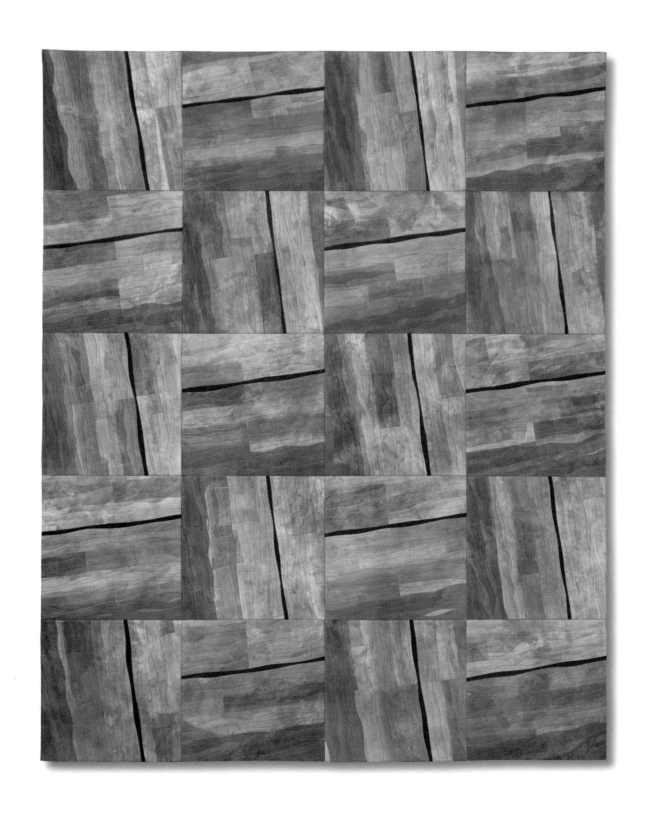

Fingerprint Series #24
Seldom Seen
36" x 36"

Direct Applique
Machine Quilted
Whole Cloth

Barbara W. Watler

Hollywood, Florida

The middle-aged contributor of this print was born with cerebral palsy which prevented using the hand. As a result the ridges (raised skin) and furrows (lowered skin) are smaller and finer than those on the other hand. There is a childlike quality to the print. Fingerprint ridges are actually formed during early fetal development. The ridges and furrows twist and divide into three major patterns of loop, whorl, and arch. Each print tells a story, revealing a bit of personal history. Intrinsic shapes within the prints change and evolve like an unknown language that is new and ancient at the same time.

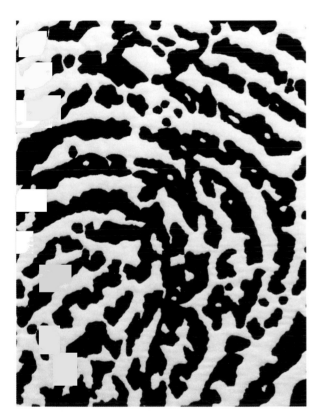

Detail

After stitching, the black top layer is cut away to reveal the white design.

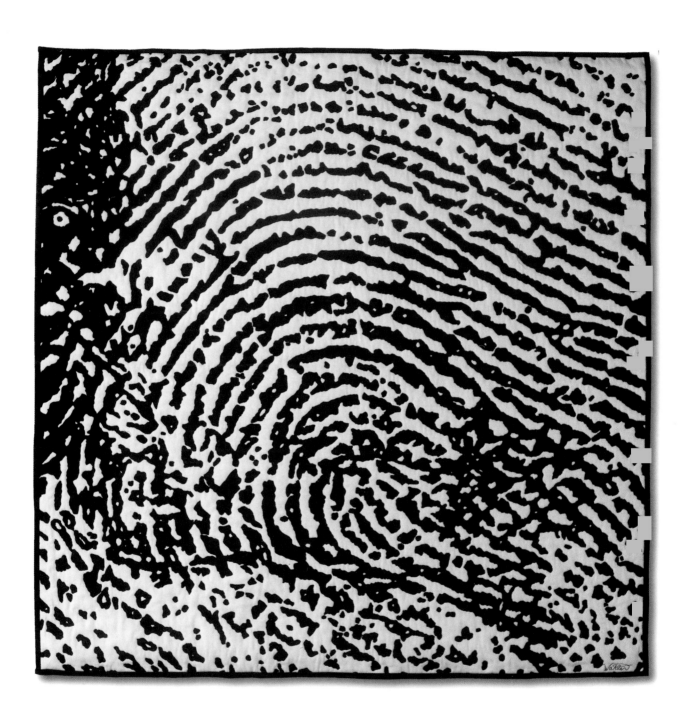

Index

Acknowledgements

It is the collective vision of many individuals that has made this, the 7th biennial exhibition of Quilt San Diego/ Quilt Visions possible. I would like to extend my gratitude and appreciation to the following individuals.

Members of the Board of Directors of Quilt San Diego/Quilt Visions:
Patti Sevier, Miriam Machell, Phyllis Newton, Marion Connaughton, Lynn Glynn, Doria Goocher, Tricia Klem, and Margrette Carr.

Jurors for **QUILT VISIONS 2002:** Inez Brooks-Myers, Rebecca Stevens, and Lynn Lewis Young.

Photographer : Mike Campos of Campos Photography.

Our catalog sponsors are Rosie Gonzalez, owner of Rosie's Calico Cupboard Quilt Shop and a grant by Friends of Fiber Art International.

Catalog cover design and layout : Doria Goocher.
Copy editing: Barbara Friedman and Margrette Carr

We are grateful to our partners in the production of this exhibit, the beautiful Oceanside Museum of Art.. The following individuals at OMA have provided invaluable assistance during all phases of the production of **QUILT VISIONS 2002:** Peggy Jacobs, James R. Pahl, Beth Smith, and Trish Williamson.

Without the support of our members, sponsors, and volunteers, exhibition of the exceptional quality of art quilts seen here would simply not be possible. Quilt San Diego is proud to be able to continue to promote the quilt as art and to provide the artists who produce such powerful work the opportunity to share their vision with a larger audience.

Julia D. Zgliniec
President, Board of Directors
Quilt San Diego/Quilt Visions

ISBN - 0-9724664-0-1

A Visions Publication
PMB# 372
12463 Rancho Bernardo Road
San Diego, CA 92128 - 2143

Printed in Hong Kong through Global Interprint.

QUILT VISIONS
2002

An Exhibition of Forty-Five Quilts

Edited by Julia D. Zgliniec

QUILT SAN DIEGO / QUILT VISIONS